Thanks

To God
For being such a great God that I could never exaggerate how awesome You are.

My dear friends, stand firm and don't be shaken. Always keep busy working for the Lord. You know that everything you do for Him is worthwhile. 1 Corinthians 15:58

To my wife Mandy
You complete me in every way possible.
I can not put into words what you mean to me but I do know
I would be nothing without you.

To Uncle Sid
You will always be the greatest drummer I've ever known.

To The Atlanta Institute of Music
Creig Harber and Tom Knight are world class teachers and out of this world drummers. Because of your instruction, I'm not only a better drummer but a better person.

In memory of my brother

Justin Forrest Edwards

PURPOSE

What is the most important thing about being a drummer?

To convey a pulse in the music you're playing in other words to **Create A BEAT!**

Not only keeping steady time, but to put feeling into the music by placing **accents** and applying **dynamics**.

you being a beginning drummer can gain a deeper understanding of how to move your body and crea the ability for a more sophisticated and much broader way to express yourself behind the drumset.

Listen, reading music is EASY.

After you learn how to hold your sticks I will teach you how to read music and within minutes you will be to able to read and play at the same time.

How to HOLD your sticks.

BUTT | **SHAFT** | **Shoulder Tip**

Learning how to hold the drumstick is often overlooked, but I feel this is important to learn from the very beginning to keep bad habits from forming.

I used what is called the

American Matched Grip

This means both hands look exactly the same
Hint's the word "Matched Grip"

The pictures below will teach you how to hold your sticks step by step.

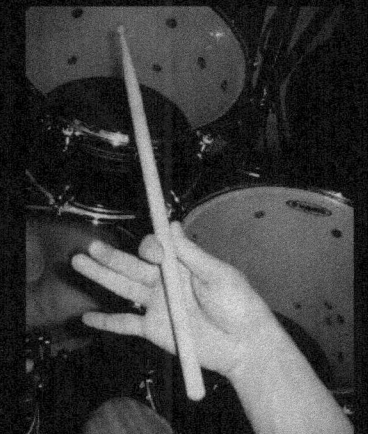

Left Hand Right Hand

Step 1

A. Check out the picture of the stick above. I have marked the area where I'd like for you to grab the stick with a star.

B. Grab and hold just below the middle of the stick with your index finger and thumb.
(About 1/3 of the way up from the bottom of the drumstick)

C. Hold it in such a way where you're not squeezing the stick so tight that it begins to hurt, but where it is able to be controlled by the thumb and index finger just tight enough not to be dropped

How to HOLD your sticks.

Step 2

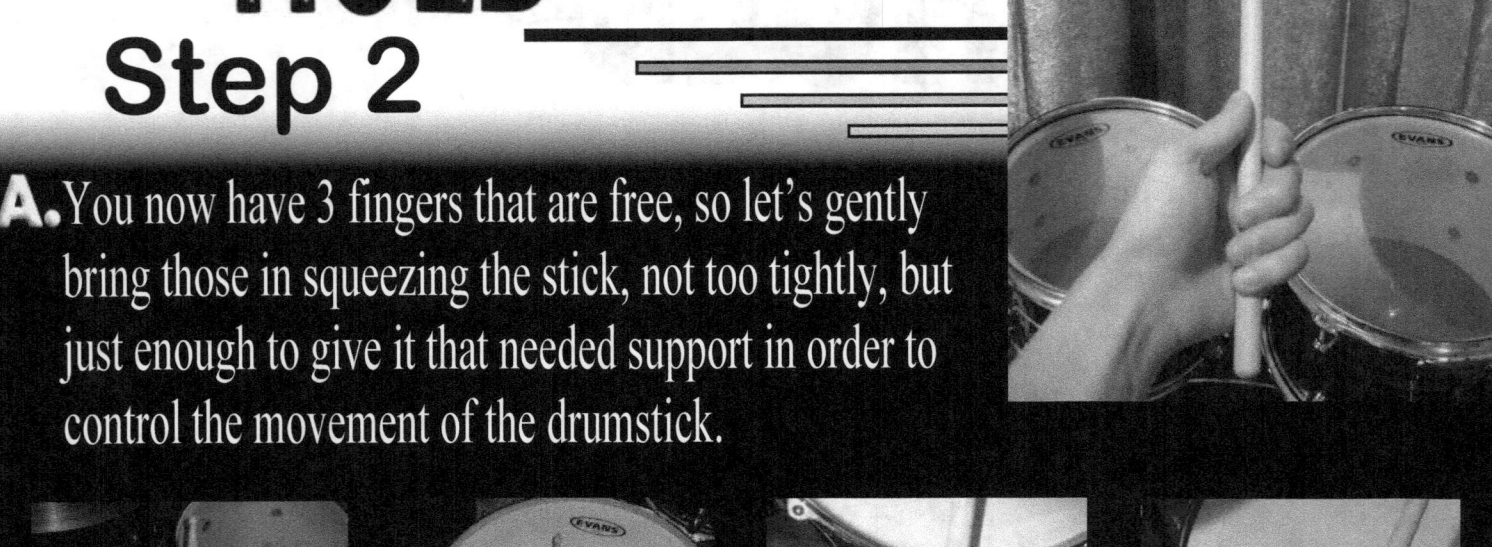

A. You now have 3 fingers that are free, so let's gently bring those in squeezing the stick, not too tightly, but just enough to give it that needed support in order to control the movement of the drumstick.

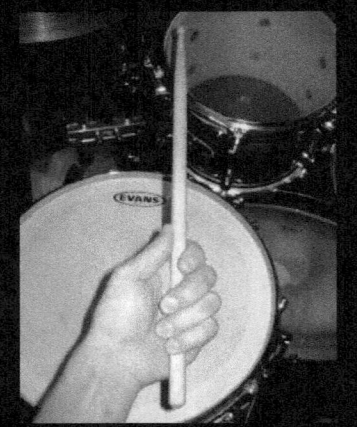 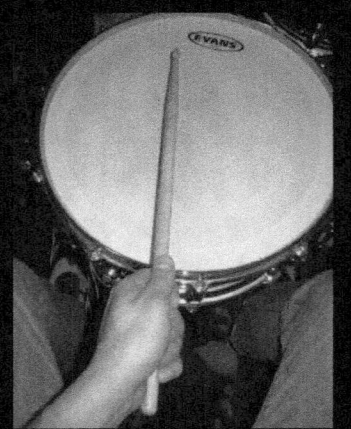 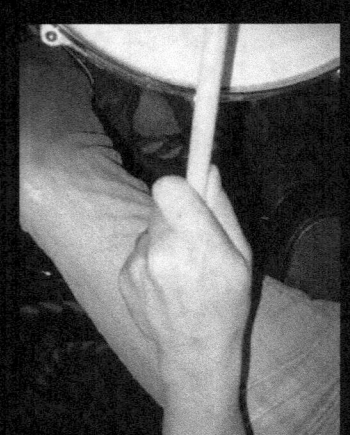 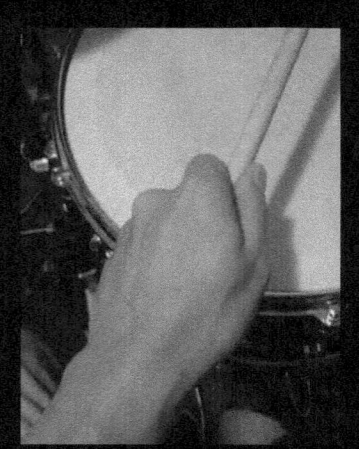

Step 3

A. Turn both your hands over so that the back of you hand is facing upward and the stick is in line with the wrist and arm.

B. Check out the thumb and index finger position again to make sure that you're going to get the best rebound out of the stick whenever you strike the drum.

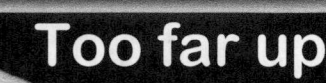
Too far up

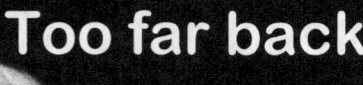
Too far back

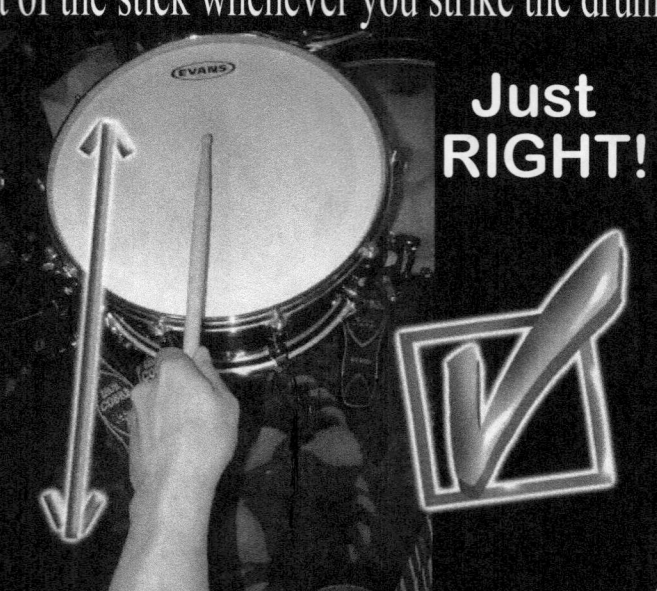
Just RIGHT!

Reading Music 101

This is called the **Staff** ⇨
this is is where all of the notes go.

What are notes?

This is called a Quarter Note ⇨

There are different types of notes but you will learn about those as you get further along in the book.

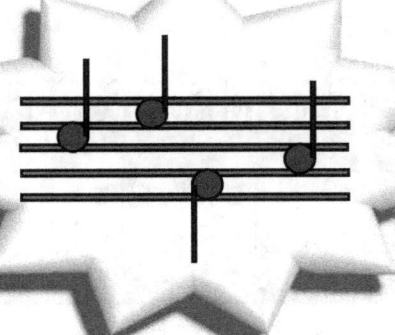 ⇦ The notes are then placed on the staff and tell you what to play and when to play it.

I told you this was easy!

Check out the staff below. What makes this staff different? Do you see anything that sticks out?

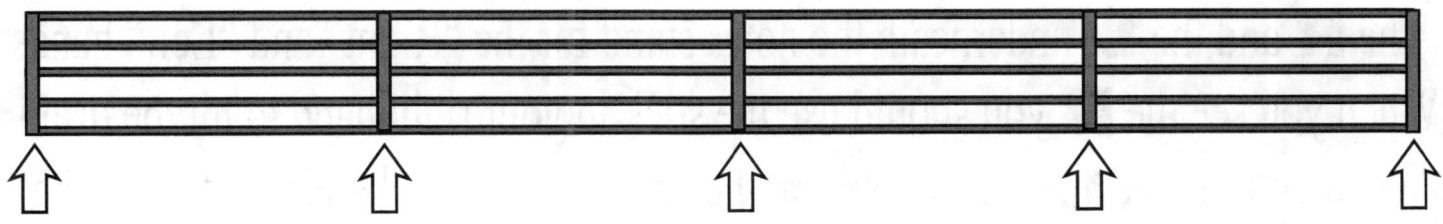

⇧ ⇧ ⇧ ⇧ ⇧

The lines that stand straight up that divide the staff are called **Bar Lines**.

Reading Music 101

In between the bar lines where the notes are placed is called a

Measure.

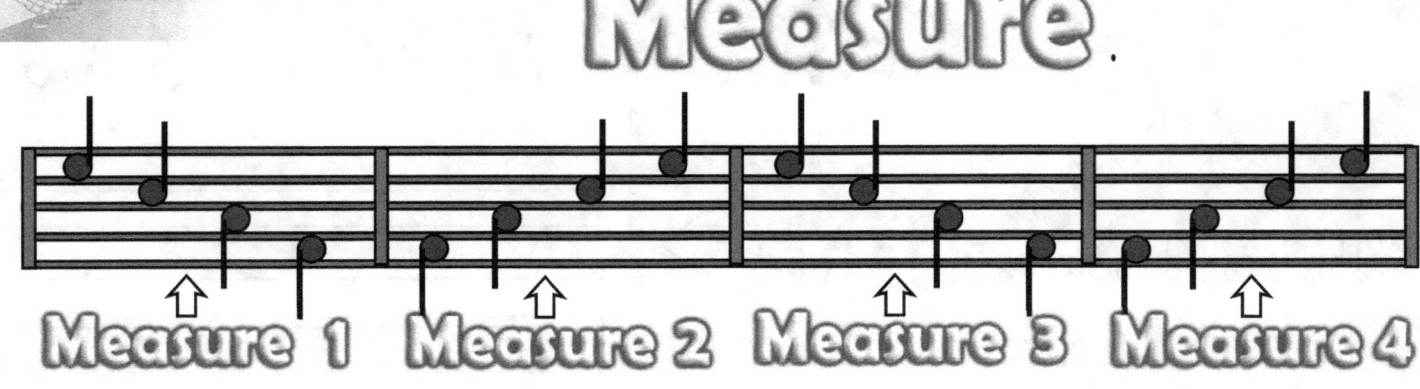

Measure 1 Measure 2 Measure 3 Measure 4

In this measure how many quarter notes do you see?

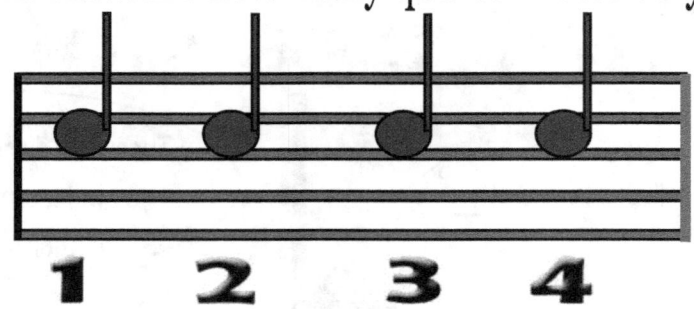

1 2 3 4

**Let's have some fun. Pick up your sticks and let's read some music!
Don't Forget To CHECK YOUR GRIP.**

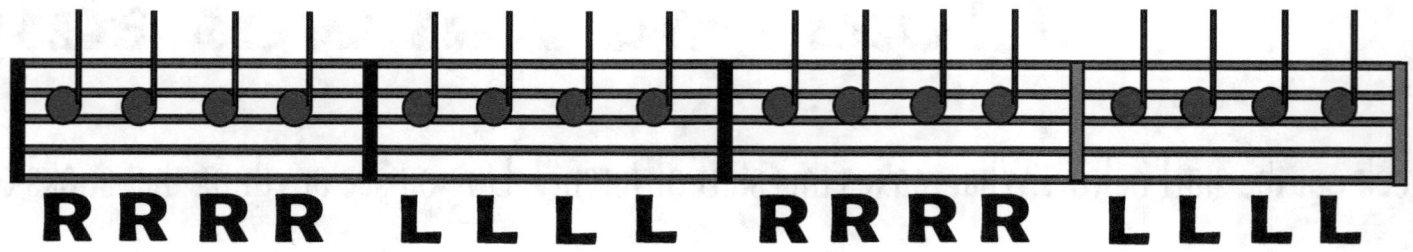

R R R R L L L L R R R R L L L L

The **R** and the **L** underneath the notes stand for the "Right" and "Left" hands. When you see the **R** you should use the stick in your right hand to hit the drum. When you see the **L** you should use the stick in your left hand to hit the drum.

Great! We're ready for our first lesson

The most important thing that a drummer has to lock in on is the **Tempo**.

The TEMPO is what determines how fast or slow a piece of music is played.
So being the drummer it is vital that you always practice to stay as close to the tempo as possible.
Try hard not to rush and get ahead of the song by speeding up,
or it is just as easy to drag or slow down, which is equally just as bad.
So STAY FOCUSED and try your hardest to stay on top of the beat.

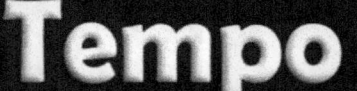

"Quarters and Sticks"

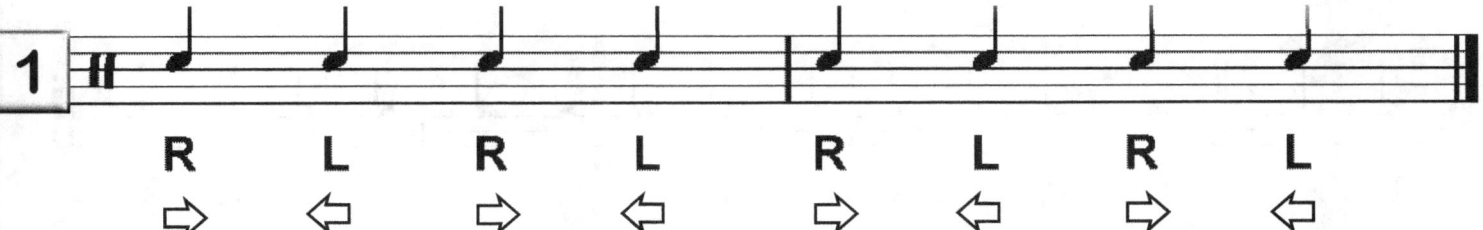

We're now playing four measures instead of two.

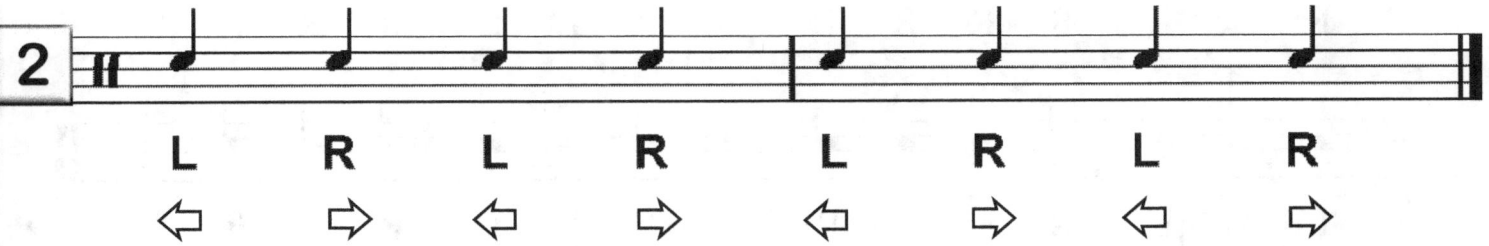

Pay attention to the patterns in the left and right hand.

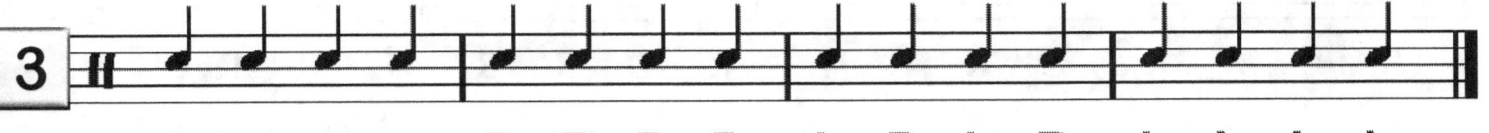

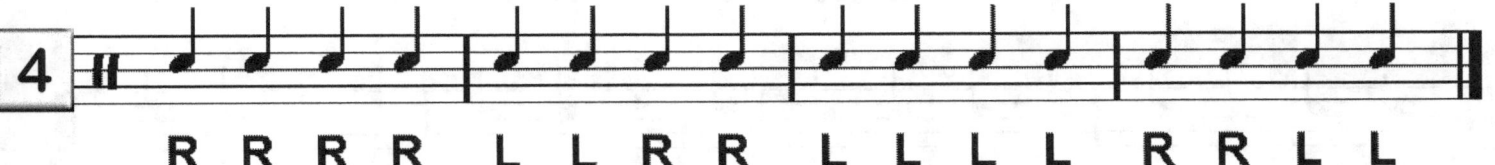

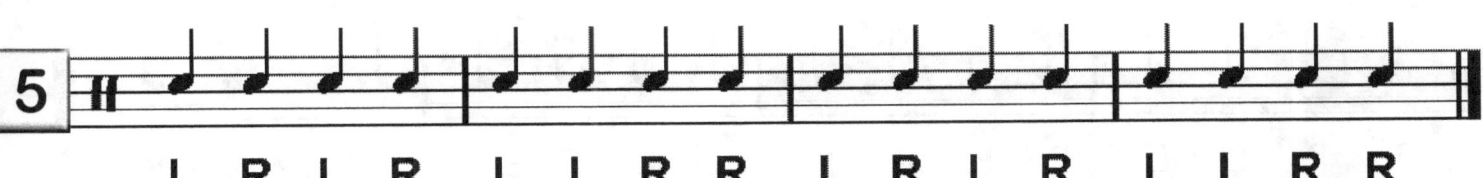

"Quarters and Sticks"

Try these exercises with a metronome. Play them at a slow tempo at first then as you get better at them build your speed up by playing them to a faster tempo.

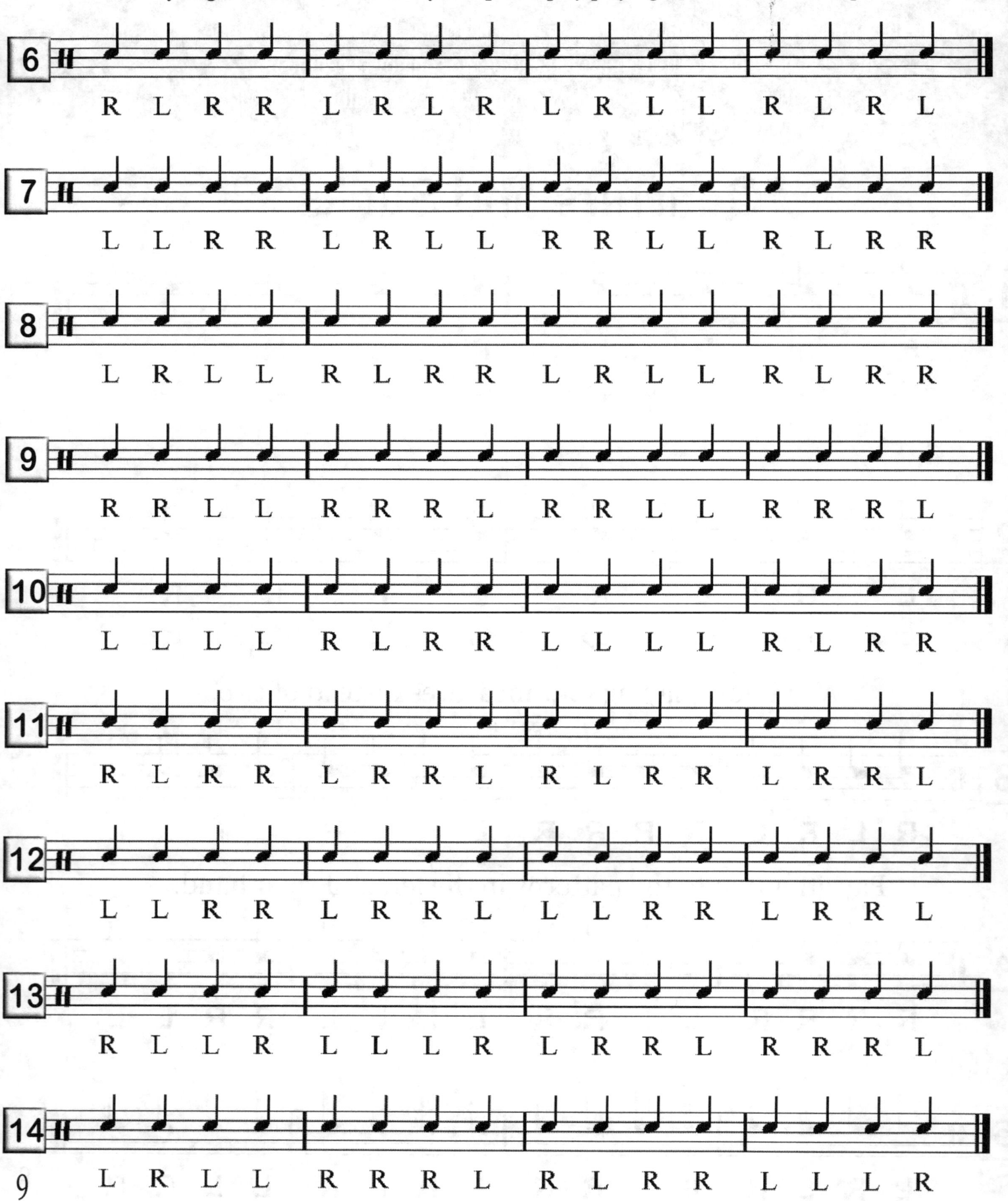

Quarter Notes & Quarter Rests

 This is a Quarter Note

← This note has a long, straight stem.

← The head of the note is oval and is always filled-in.

For every ACTION there is an equal and opposite REACTION

 This is a Quarter Rest

← This rest kind of looks like a crooked "S"

← Just like the quarter note it is always filled-in.

The Quarter Rest is the exact opposite of the Quarter Note.

What I mean by this is that so far you've learned that when you see a Quarter Note you're supposed to strike the drum and the note last for one full beat right?
So if a rest is the exact opposite of a note then that would mean when you play a Quarter Rest you should not play anything at all for one full beat, you have to give the Quarter Rest one full beat of *SILENCE*.

The following examples are to help show you what Quarter Notes and Rests look like when they are written together on a sheet of music.

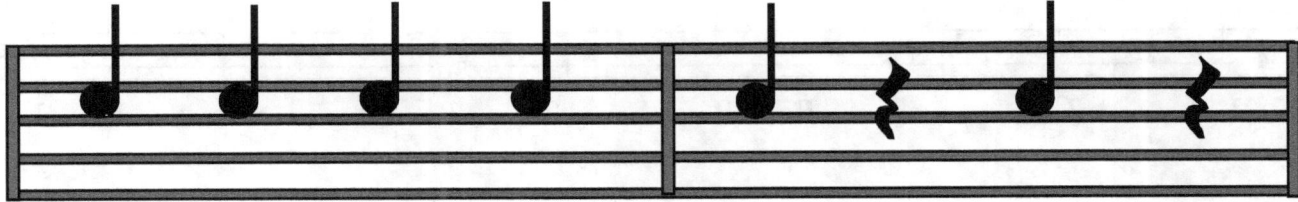

Notice that BOTH the note and the rest take up a full beat.

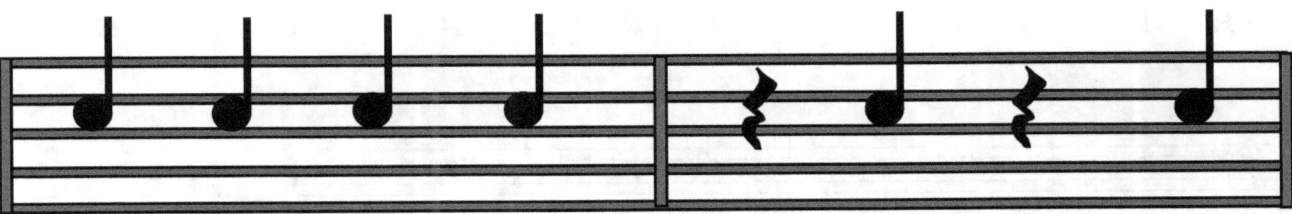

10

"Quarters Notes & Quarter Rest"

Remember that both a quarter note and quarter rest take up one full beat.
Play the following exercises with a metronome at a slow tempo at first while keeping a steady pulse.
Then progressively build up speed as you become more comfortable with the patterns.

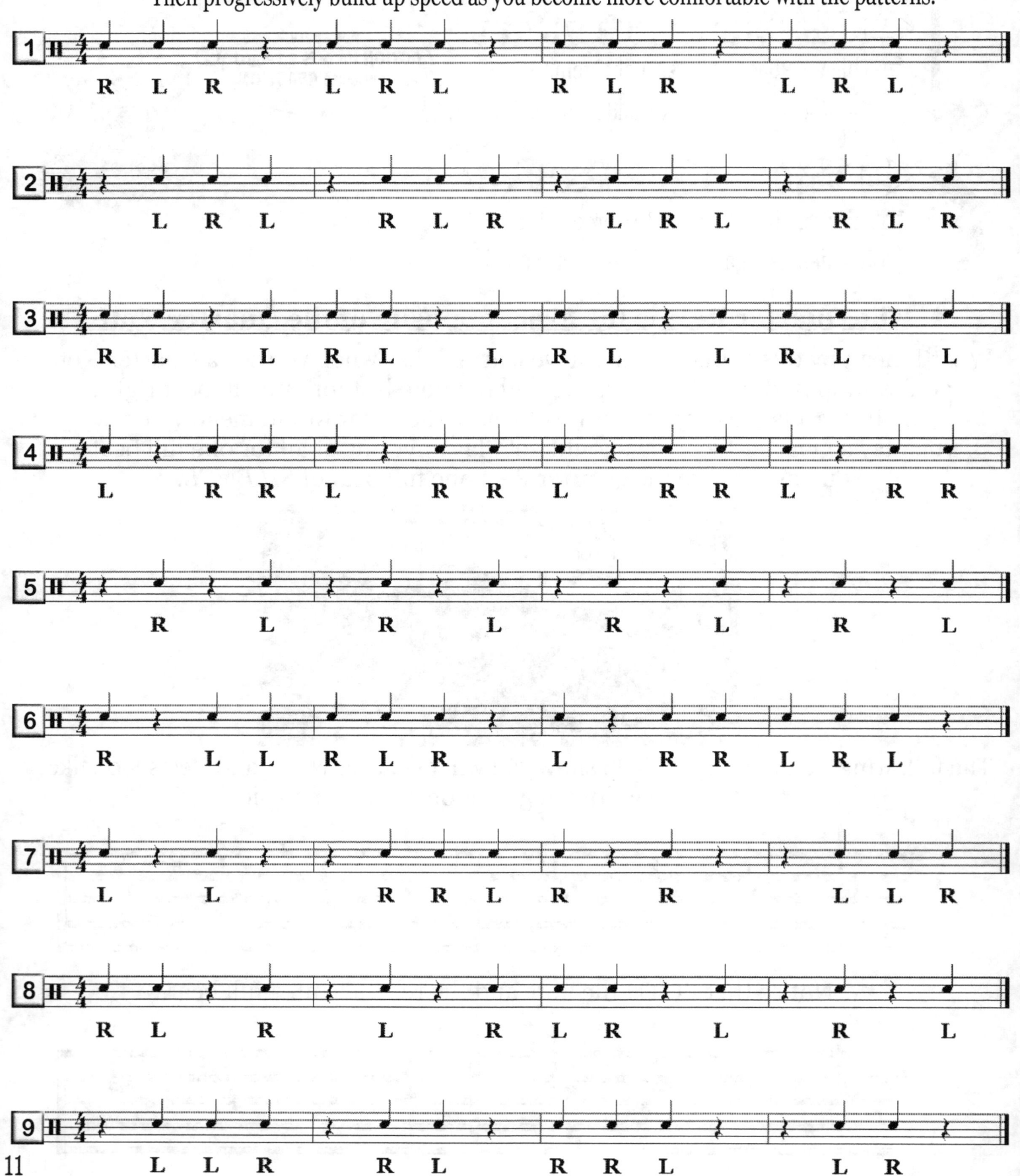

ACCENTS

I think one of the most important things that a drummer should learn early on is how to play an accent. So often times this gets neglected until the drummer has already picked up some difficult habits to break. That's why I'm introducing the accent so early on is because not only does the accent have a lot to do with the development or the feel of a groove but it also comes into play with drumset independence and the ability to work them into any part of ones library of grooves or drum-fills. So that being said....

What does an accent look like???

← **This is a Dynamic Accent**
← It looks like a horizontal V.
← It always points towards the right.

The Accent is often written above the note that is supposed to be accented

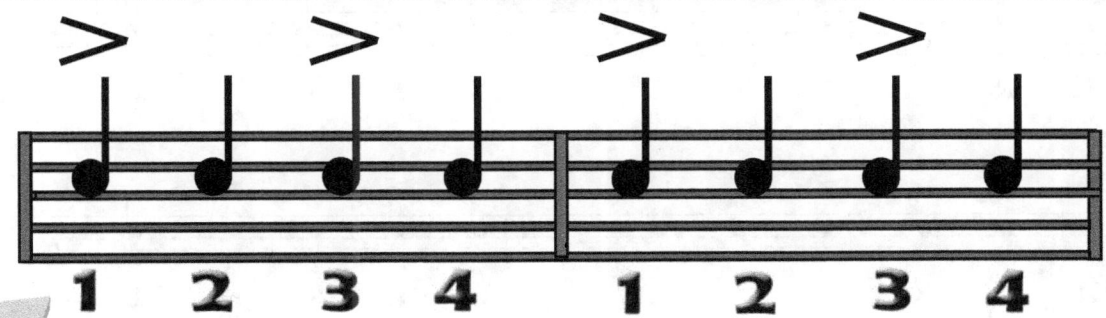

What does an accent do???

The accent means that you play the note that has an accent louder than the notes that don't have an accent.

That would mean in the example above that Beats 1 and 3 would be played louder While Beats 2 and 4 would be played at a normal volume.

ACCENTS
Let's try some exercises that include all we've learned so far

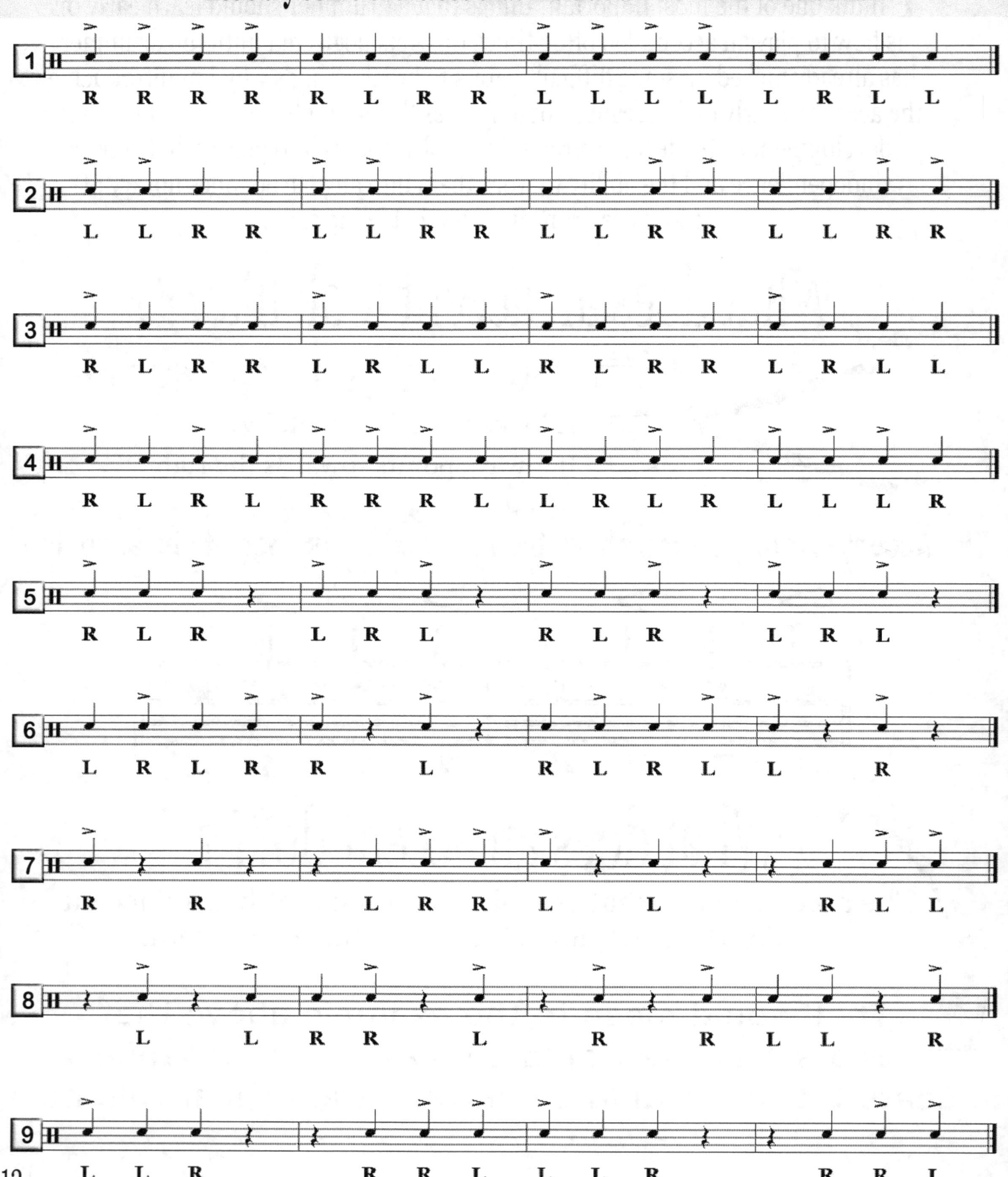

You've now learned how to use both you right and left hands playing Quarter Rest and Quarter Notes. The following exercises are going to require you to use not only your hands but will also require you to use both your right and left feet.

Music written for the modern drummer is unique because of the different types of drums and cymbals that make up the drumset. Because the drumset has so many individual sounds each part has it's own individual line or space within the staff. Let's get to know the parts of the drum set in detail and then let's find out how they are written and charted out on paper.

So let's become familiar with the pieces of your drumset

- Crash Cymbal
- Ride Cymbal
- Snare Drum
- Tom 1
- Tom 2
- Floor Tom
- HI-HAT
- Kick Drum

The Kick Drum or also known as the Bass Drum
is the largest drum of the drumset normally 22 inches wide. It's struck by a bass drum pedal you play with your feet and often holds Tom 1 and 2 above the batter side.

The Snare Drum
is typically 14 inches wide and has a strand of wires on it's underbelly that gives it it's unique sound. It should be set up at a height where the arms lay parallel above it's striking surface placed in between the drummers thighs.

Tom 1 and Tom 2 are also known as Rack Toms
There is usually more than one Rack Tom on a drumset. The Rack Tom(s) sit above or are mounted to the bass drum in some way or another. They vary in size in both width and depth ranging in sizes from 6-13 inches wide. Try to keep these as close together as possible and at the same height according to the top rim of the drums. This keeps you from extending your arms and keeping them close to your body and reducing fatigue when playing.

The Floor Tom
The Floor Tom normally has 3 feet attached to the drum so that it stands on it's own just to the right of your right leg, below the Rack Toms above. The height should be parallel to the Snare drum and slightly tilted towards you. The Floor Tom is the 2nd largest drum in your drumset and normally ranges in size from 14-18 inches.

The Ride Cymbal

The Ride cymbal sits on a stand to the right of the Rack Toms and behind the Floor Tom. You want to make sure that the Ride Cymbal is not too far out to where you can barely reach it with the stick but also not too close where it may cover up the Rack Toms or the Floor Tom. It can be at any height as long as you feel comfortable when you play it. The Ride Cymbal is also the largest of the cymbals and is normally between the sizes of 18-22 inches.

The Hi-Hat

The Hit-Hat is probably the most involved part of the drumset. It consist of a Hi-Hat Stand and two Hi-Hat Cymbals which are called the Top Hi-Hat Cymbal and the Bottom Hi-Hat Cymbal. The Hi-Hat sits above and to the left of the Snare Drum. Remember when placing the Hi-Hat you don't want it to be so far away to the left that you have trouble hitting it but at the same time you do not want it so close that you can't play the Snare Drum.

The Crash Cymbal

The Crash Cymbal like the Ride Cymbal sits on a cymbal stand and really has no one set position because it's up to you and your taste. Most often when a drumset has one crash cymbal it will sit on the opposite side of the Ride Cymbal behind the Snare Drum to the left of the Rack Toms. Make sure that however many Crash Cymbals you may have that you don't put them so high to where you can't get around the drumset after hitting them.

Reading Music for the Drumset

In music written for the drumset you will often see this.

Ride Cymbal
Snare
Kick
L. F. Hi-Hat

This is called a Key. You will more than likely see this at the beginning of a sheet of music or in the beginning of a book. It tells you where each part of the drumset is going to be notated on the staff.

Let's start with the Right Hand playing the Ride Cymbal.

1

Now with the Left Hand let's play the Snare Drum.

2

Now play the Kick Drum with your Right Foot.

3

Finally, play the Hi-Hat by just pressing the pedal wit your Left Foot.

4

Reading Music for the Drumset

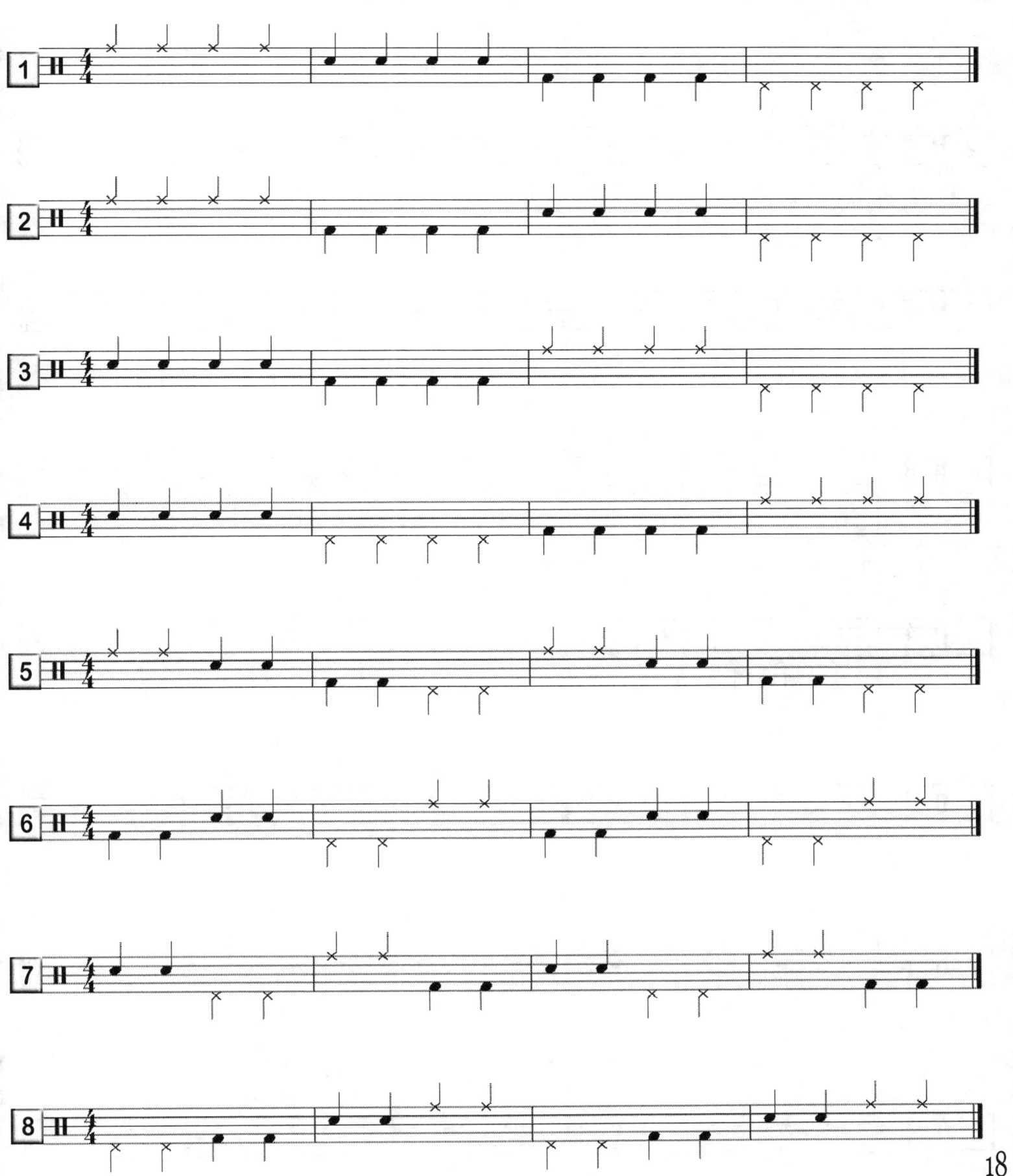

Reading Music for the Drumset

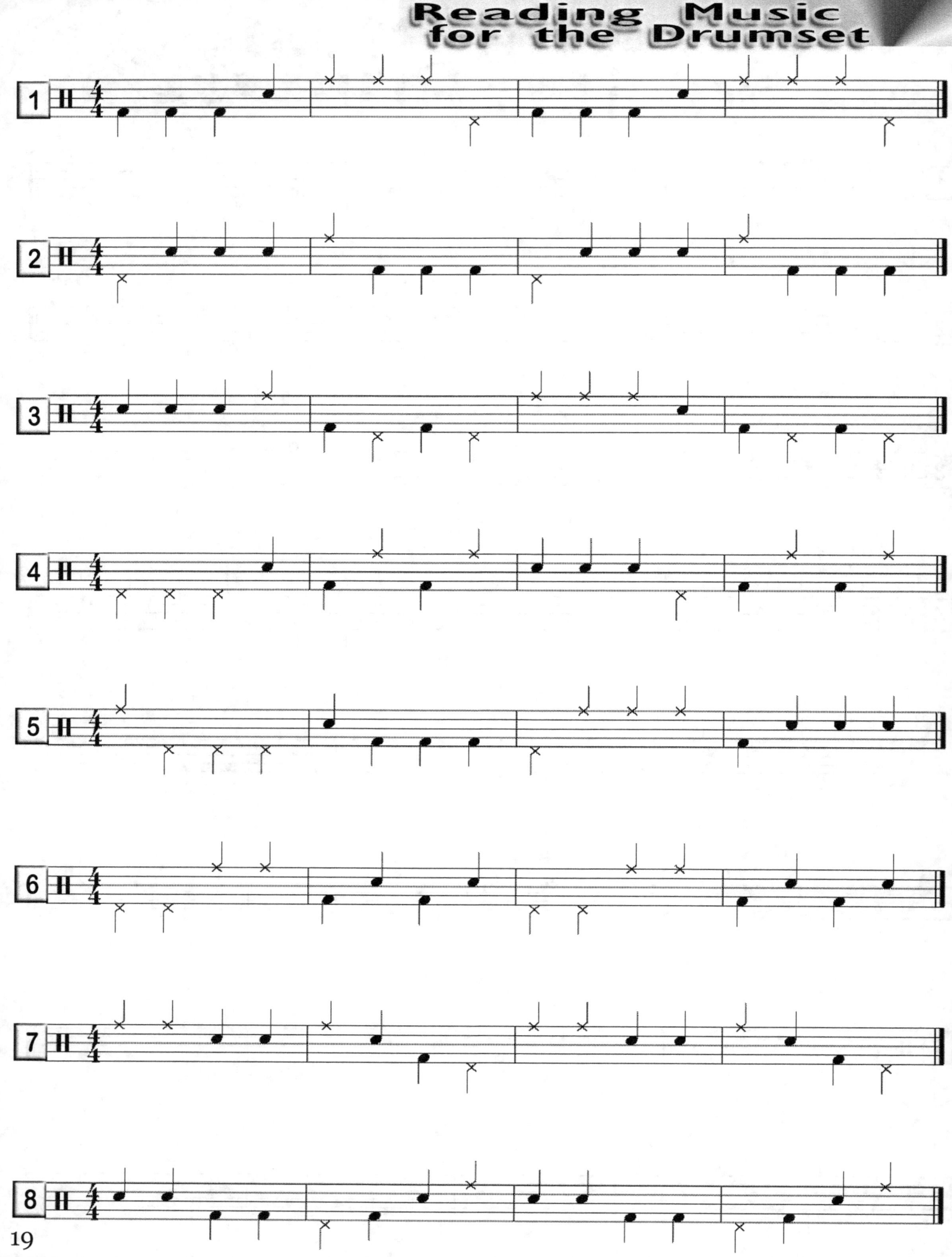

Time Signatures

In the previous section you might have noticed something different about the staff. If you flip back you will see something that looks like this at the beginning of each exercise:

This is called a Time Signature.

How many beats are in a measure

The kind of note that occupies one beat

The Time Signature is a fraction sign located at the beginning of a piece of music that explains how the song will feel.
<u>The number on top indicates how many beats are in a measure.</u>
<u>The number below represents the kind of note that takes up a full beat</u>

What is a Beat?

A beat is what you clap your hands to or tap your feet to while your listening to a song. It's the very basic time unit in music. It's reveals a pulse in the music to give it feeling.

How is a Beat measured?

Let's say that your favorite song is playing on a MP3 player or a CD player. While it's playing there is a timer that shows you in minutes and seconds how long the song is. Because music is measured by time it is organized by breaking down the amount of beats that go into a minute. The more beats played in a minute the faster the Tempo feels. The opposite of this is true as well. The fewer beats a minute the slower the Tempo is going to feel.

Playing 2 limbs at the same time

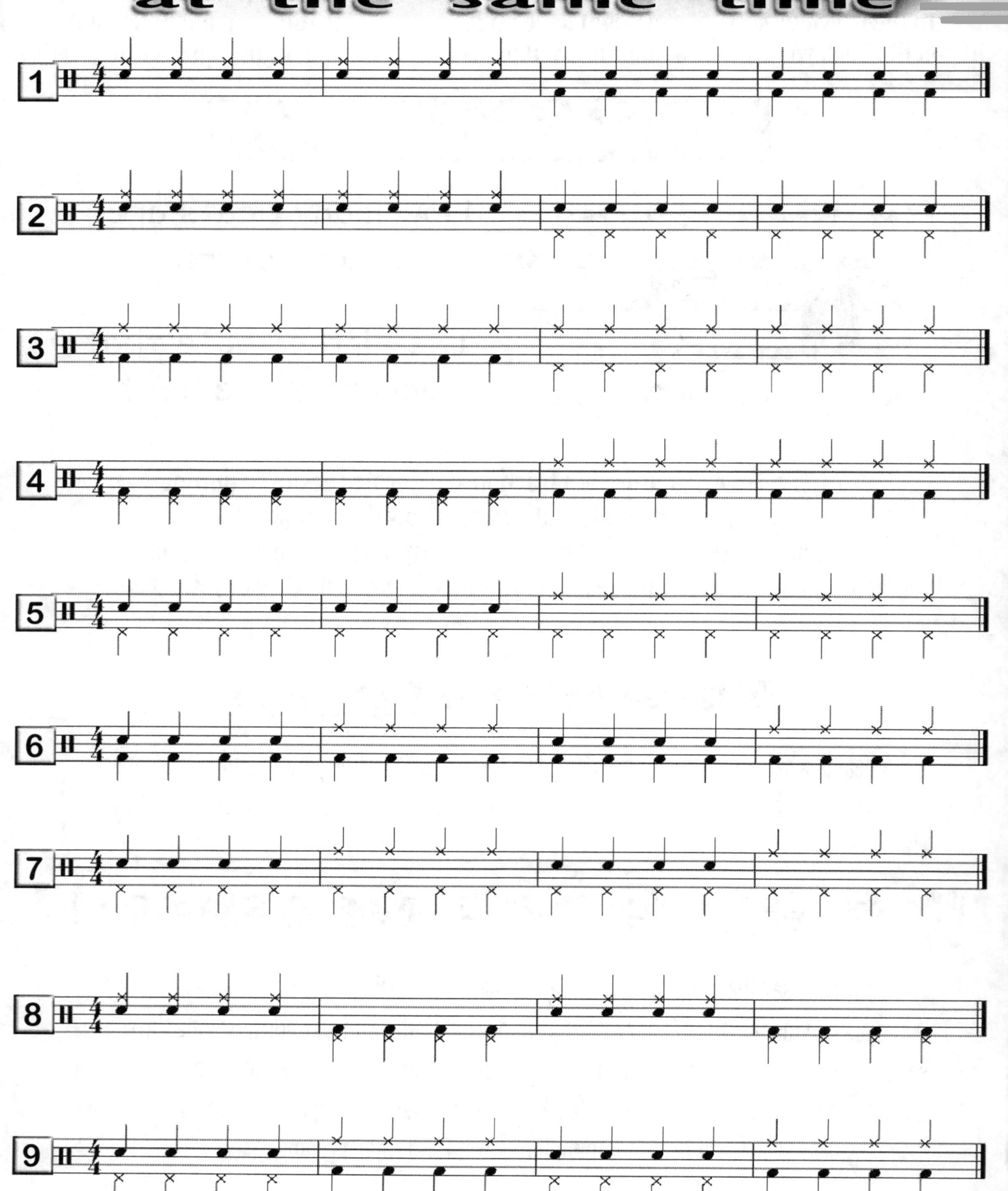

Playing 2 limbs at the same time

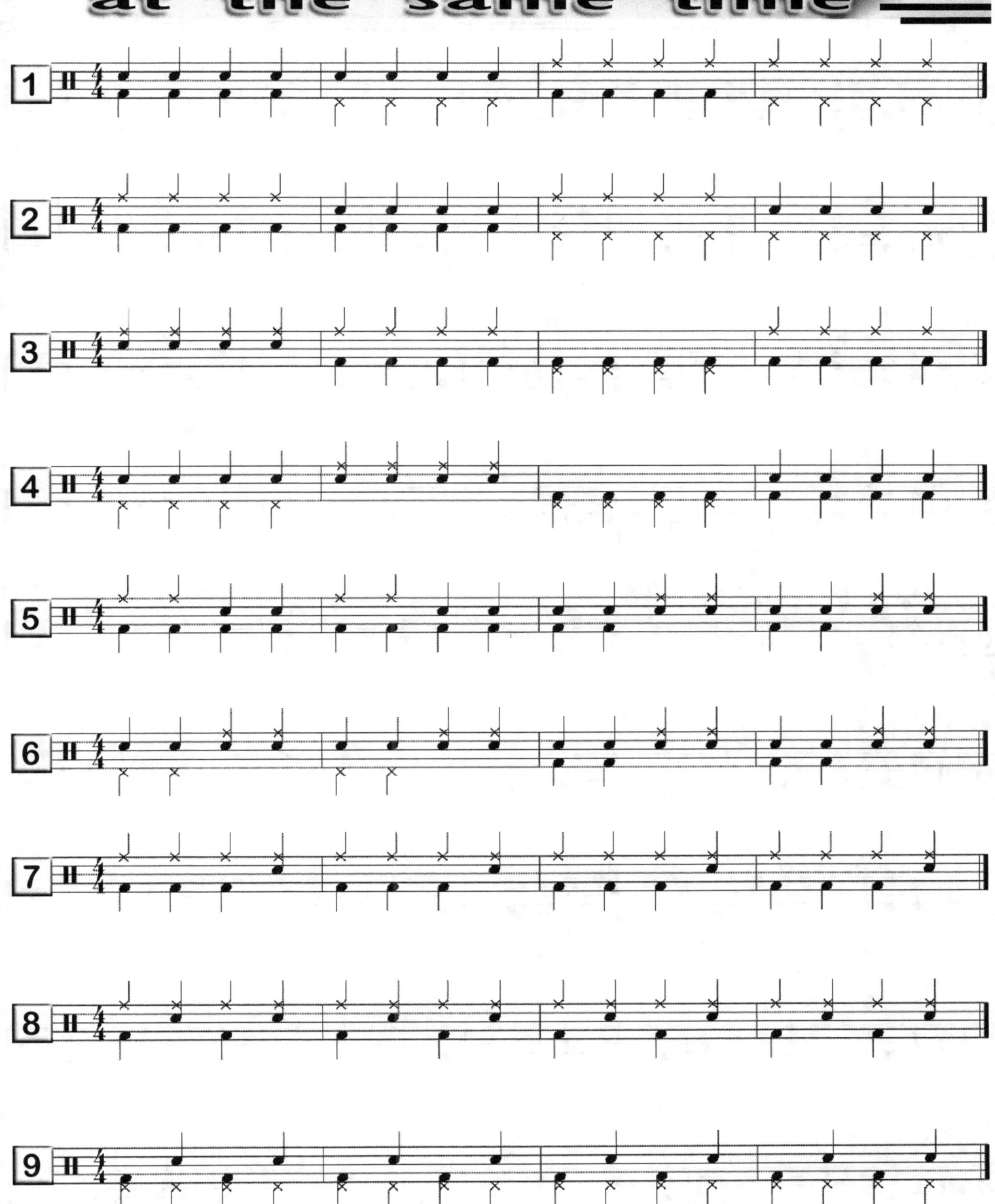

Quarter Note Grooves

LET'S ROCK!

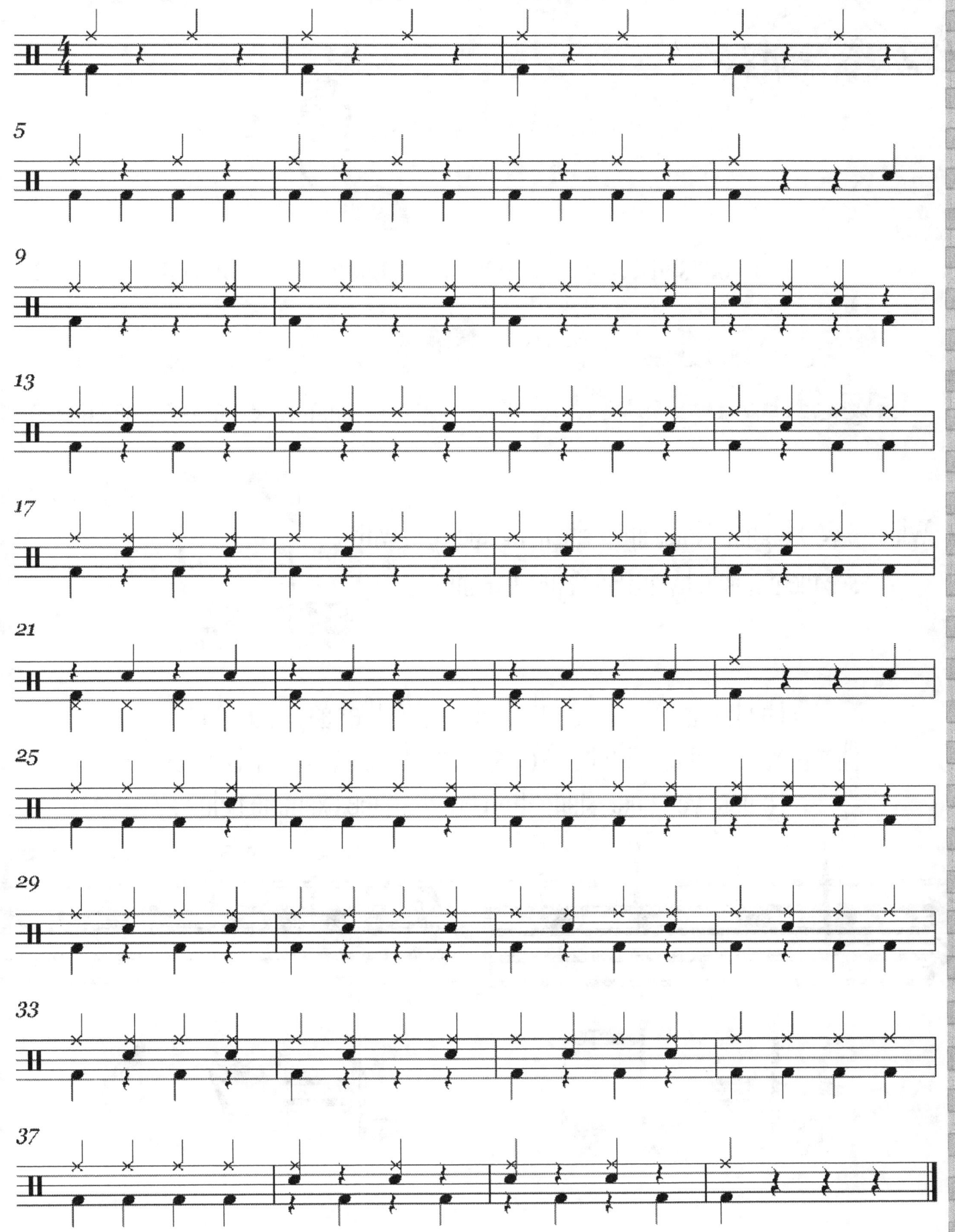

Learning to play Eighth Notes

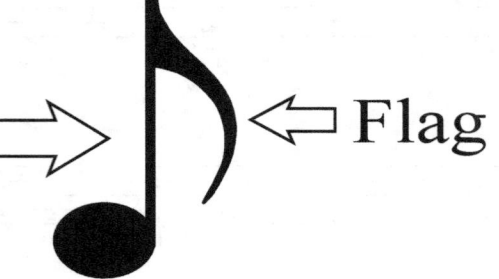

This is called an Eighth Note ➡ ⬅ Flag

It looks just like a Quarter Note but it has a Flag added to it's stem.

This is the Eighth Note Rest ➡ ⬅ It kind of looks like the number seven with a ball on top.

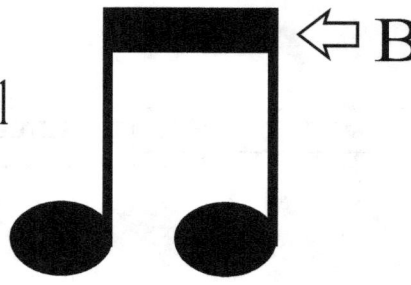
⬅ Beam

When TWO Eighth Notes are written together you will see them linked by a BEAM just like this.

The Eighth Note takes the value of Half of a Quarter Note.
That means it takes 2 Eighth Notes to equal the value of 1 Quarter Note.
To help you understand this check out the example below.

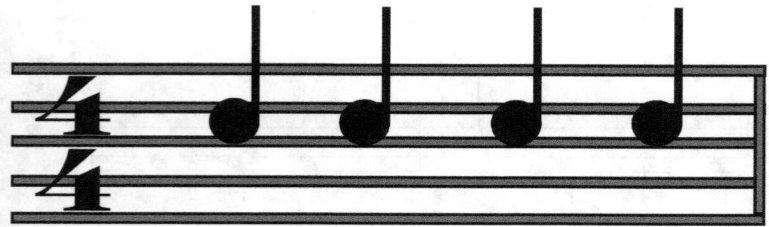 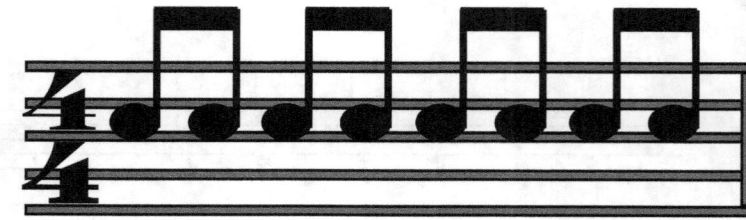

 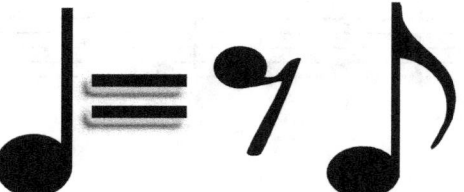

Playing Eighth Notes

Playing Eighth Notes

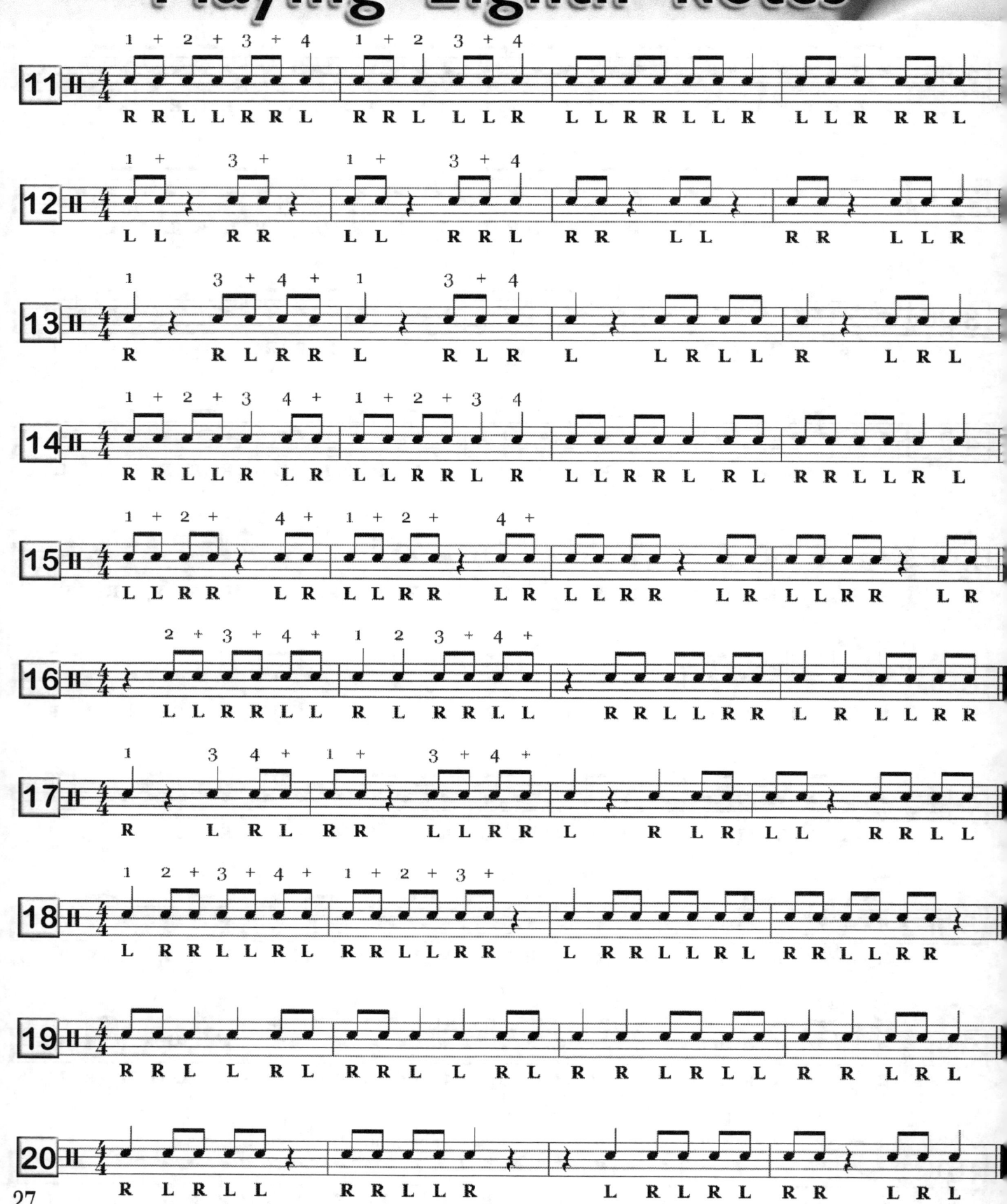

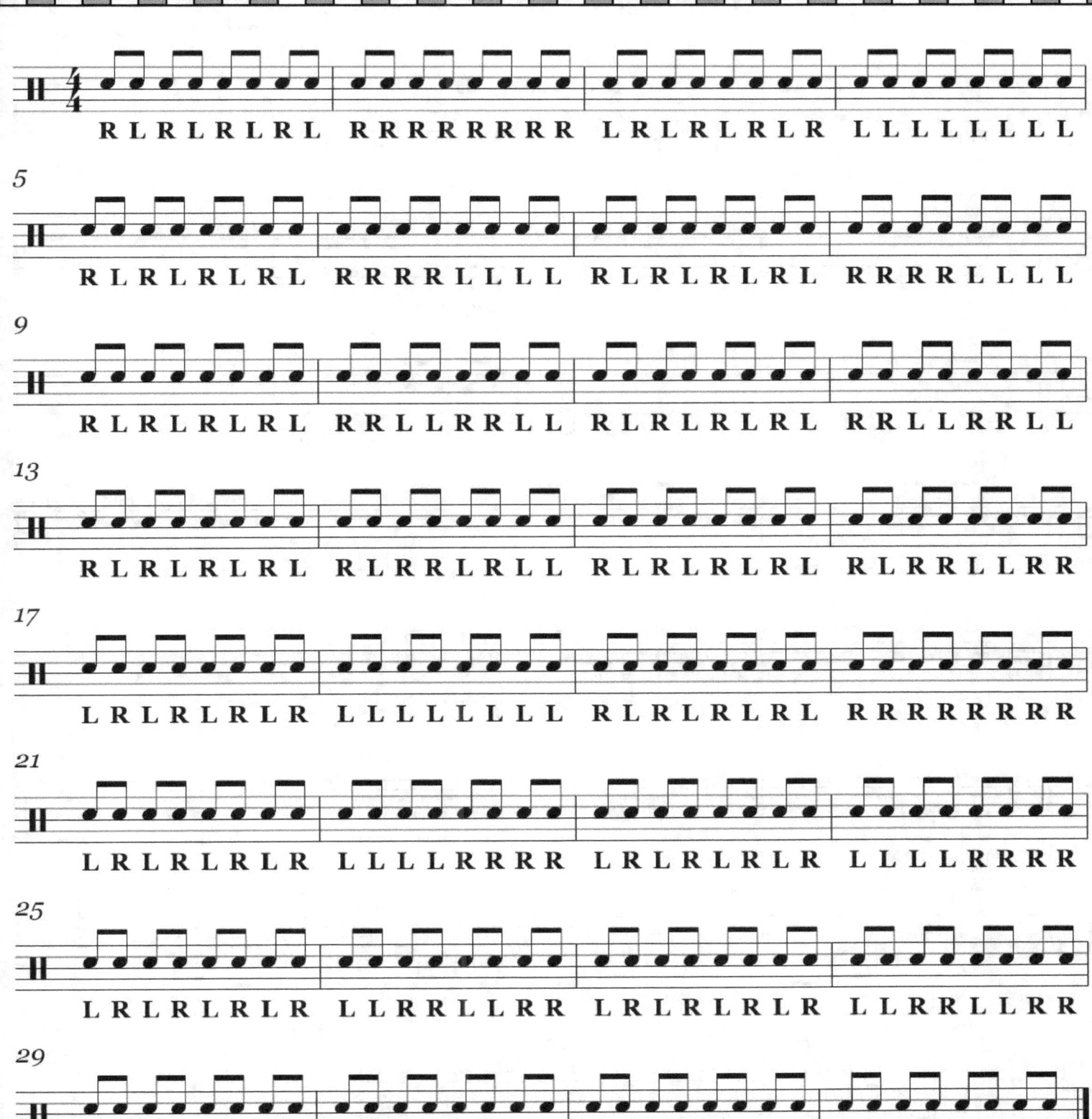

Independent Eighths

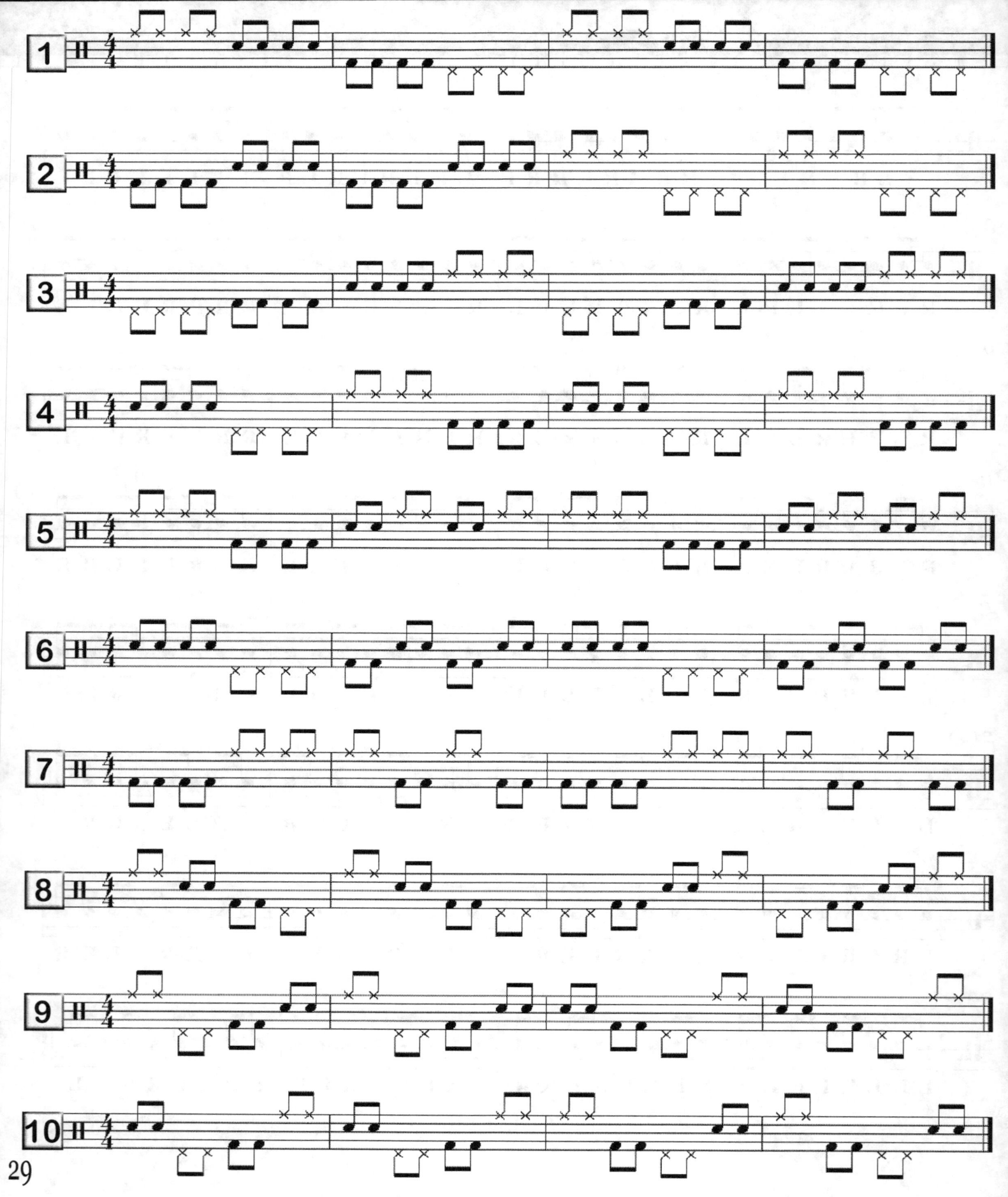

The WHOLE and HALF NOTE

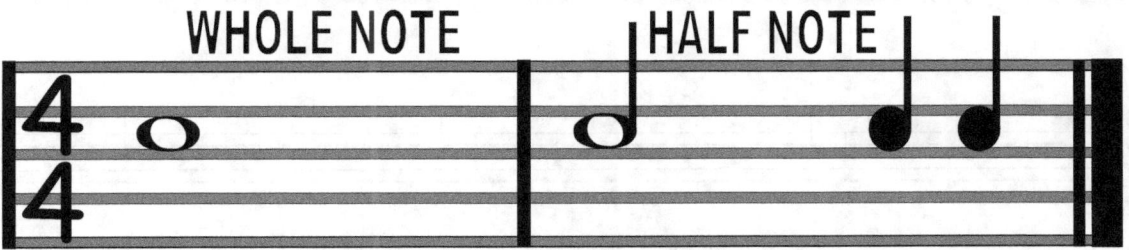

Notice the Whole Note. It has the length of 4 Beats and is represented by a hollow oval. When playing a Whole Note, hit the drum once on beat and 1 and count 2 - 3 - 4.

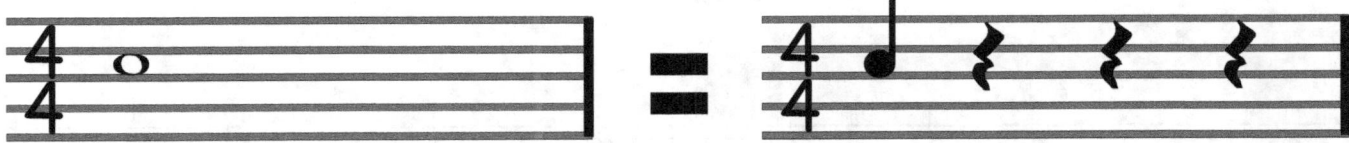

The Half Note is played HALF the length of a Whole Note.
It has the length of 2 Beats and like the Whole Note it has a hollow shaped, oval note head but the difference between the Half Note and the Whole Note is that the Half Note has a stem.

When playing a Half Note, hit the drum once and then rest the next beat.

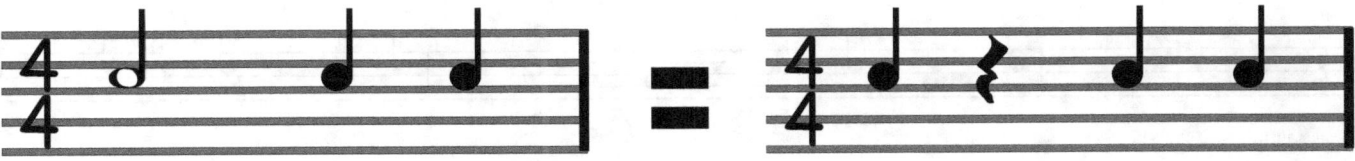

The WHOLE and HALF REST

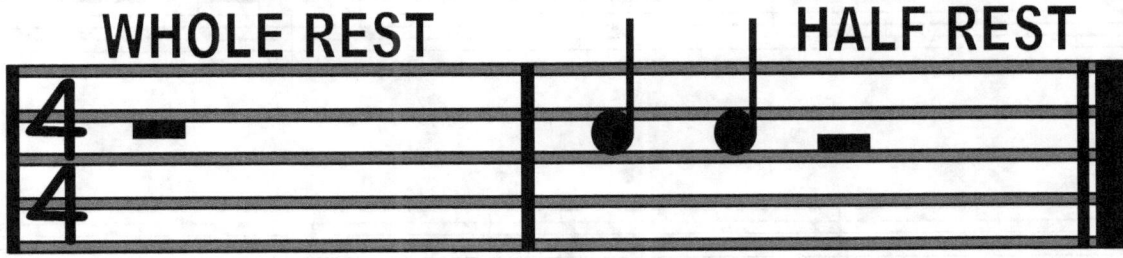

The Whole and Half Rest are identical in the way they look. They are both solid rectangles but it is the placement of where they fall on the Staff that makes them different.
As shown in the example above the Whole Rest **hangs** from the line and takes up a 4 beats and the Half Rest **sits** on the line and takes up 2 beats.

Wholes & Halves

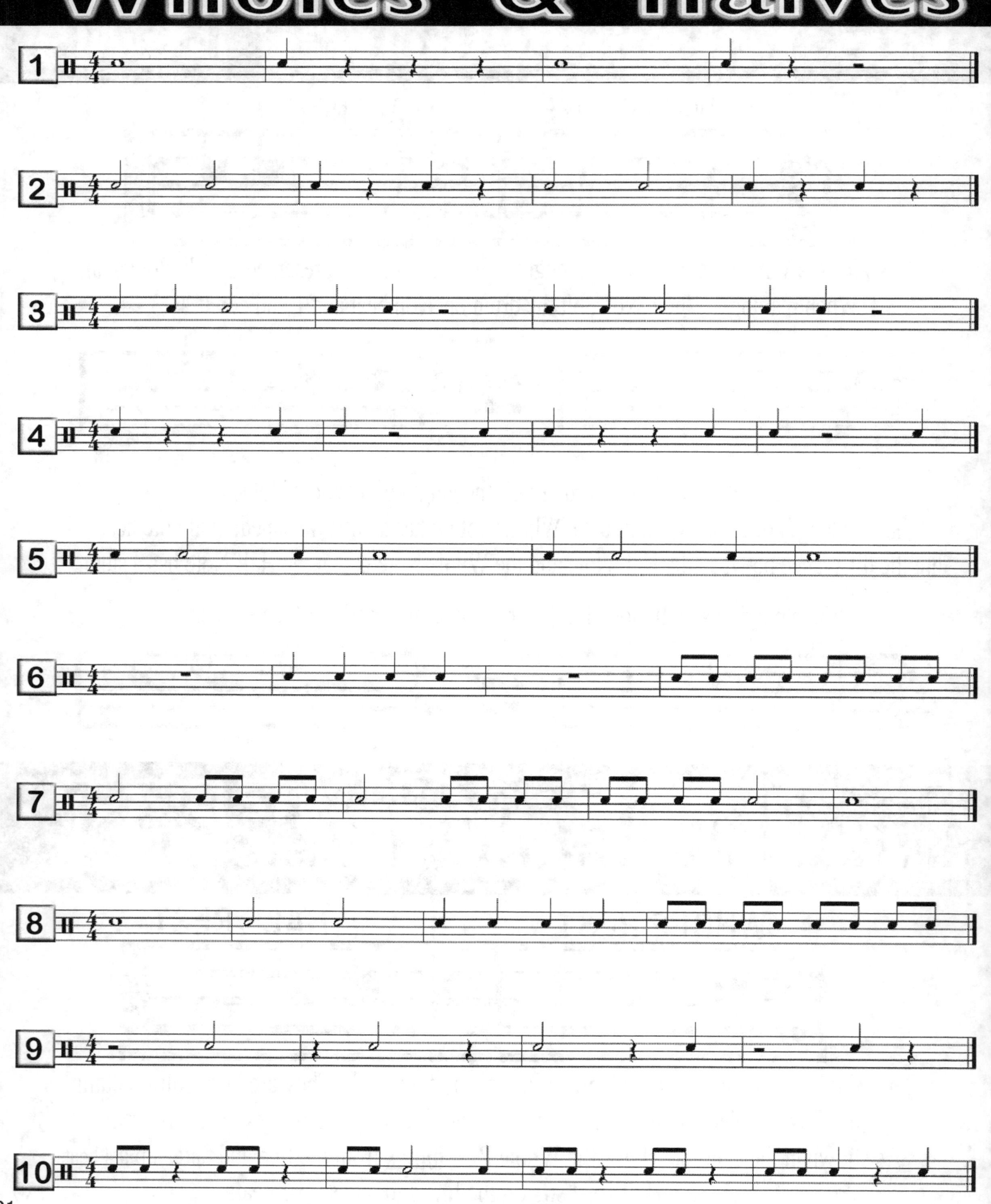

||: Play It Again :||

When composing and reading music there are often parts that repeat themselves. So instead of writing out every single measure the composer will use what is called a **Repeat Mark**. It not only saves the composer a lot of time but it also saves a lot of paper and leads to less confusion while playing the music.

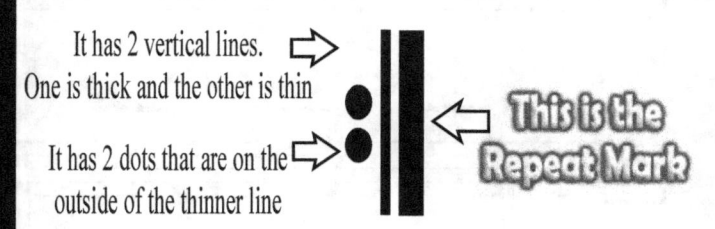

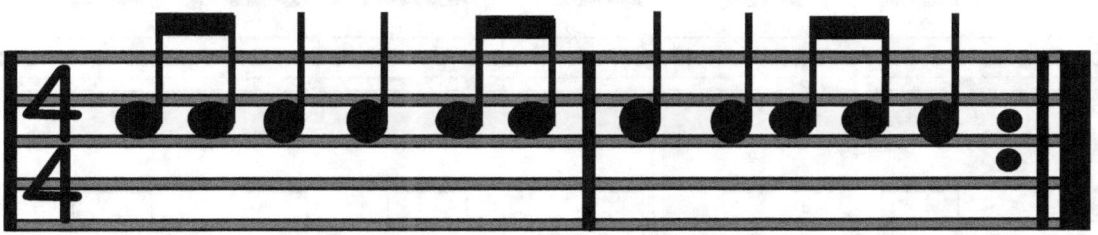

Play to the Repeat Mark

When you hit the Repeat Mark go back to the beginning

and play the music again to the end.

When you see the Simile Mark in a measure it means to repeat the previous Measure.

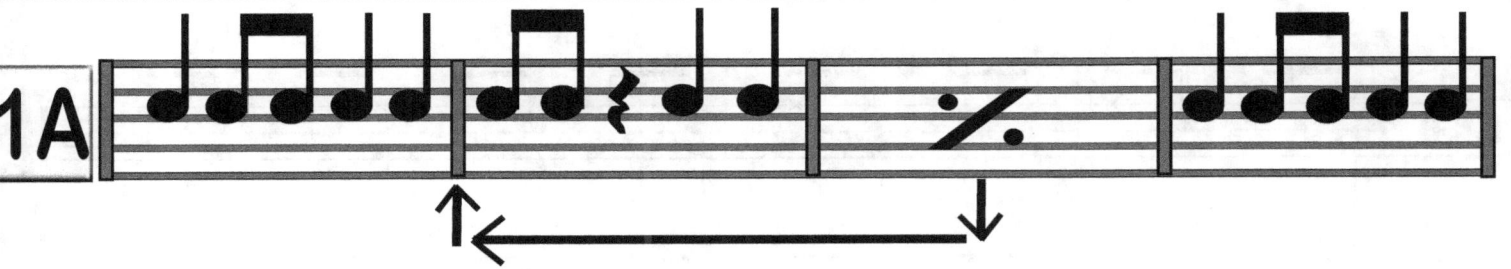

The exercise 1A above will play like this

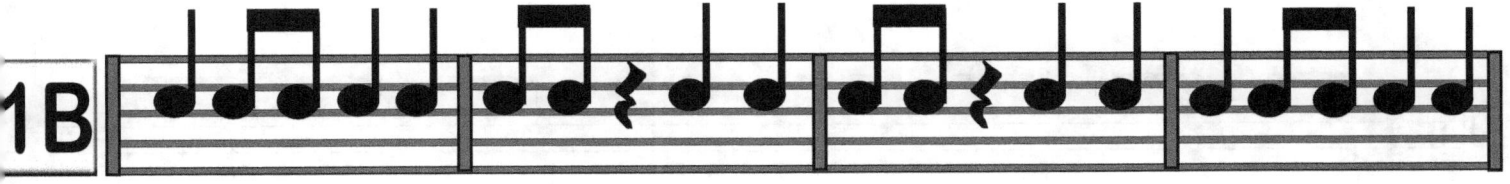

8th Note Drum Grooves

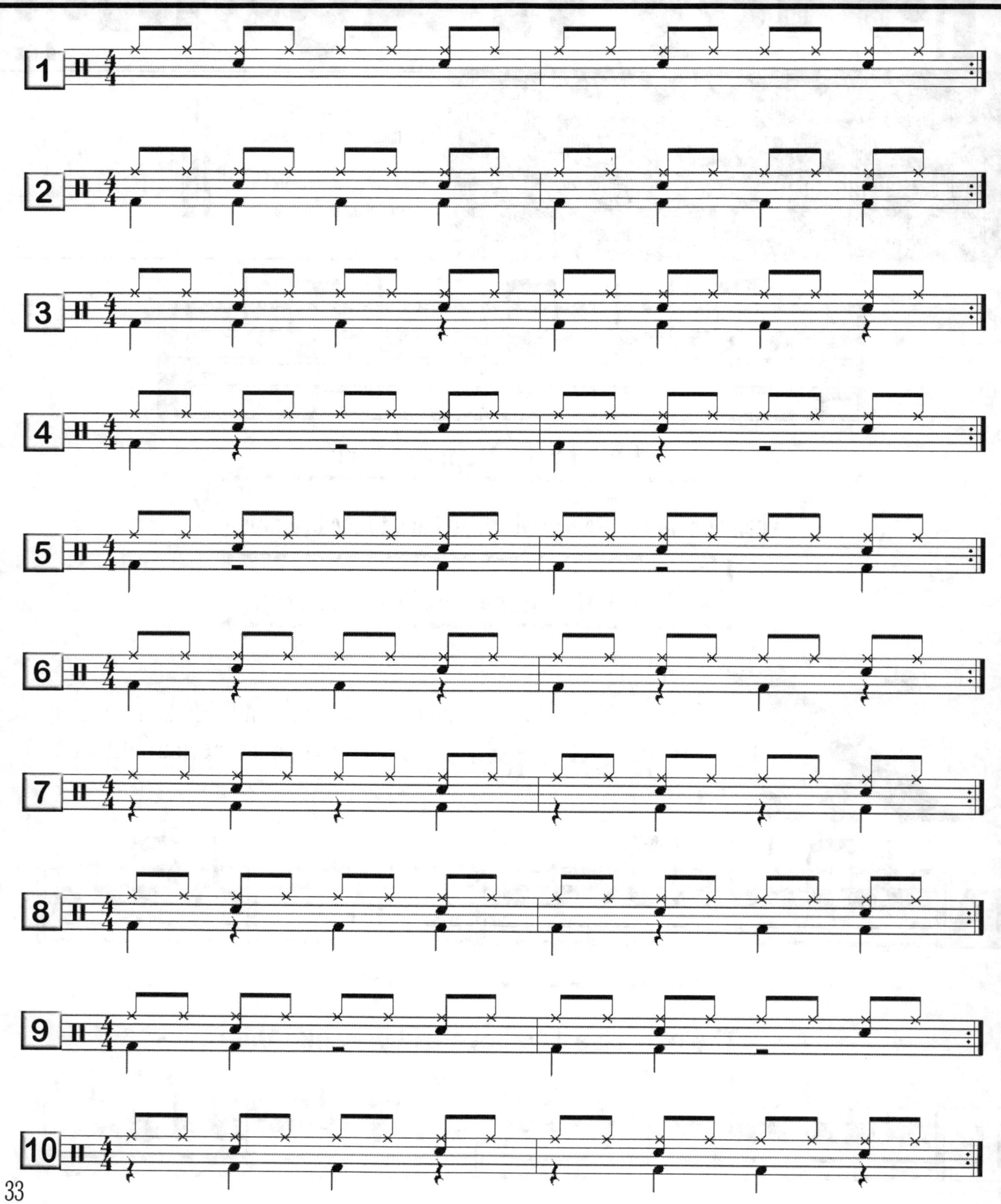

8th Note Drum Grooves 2

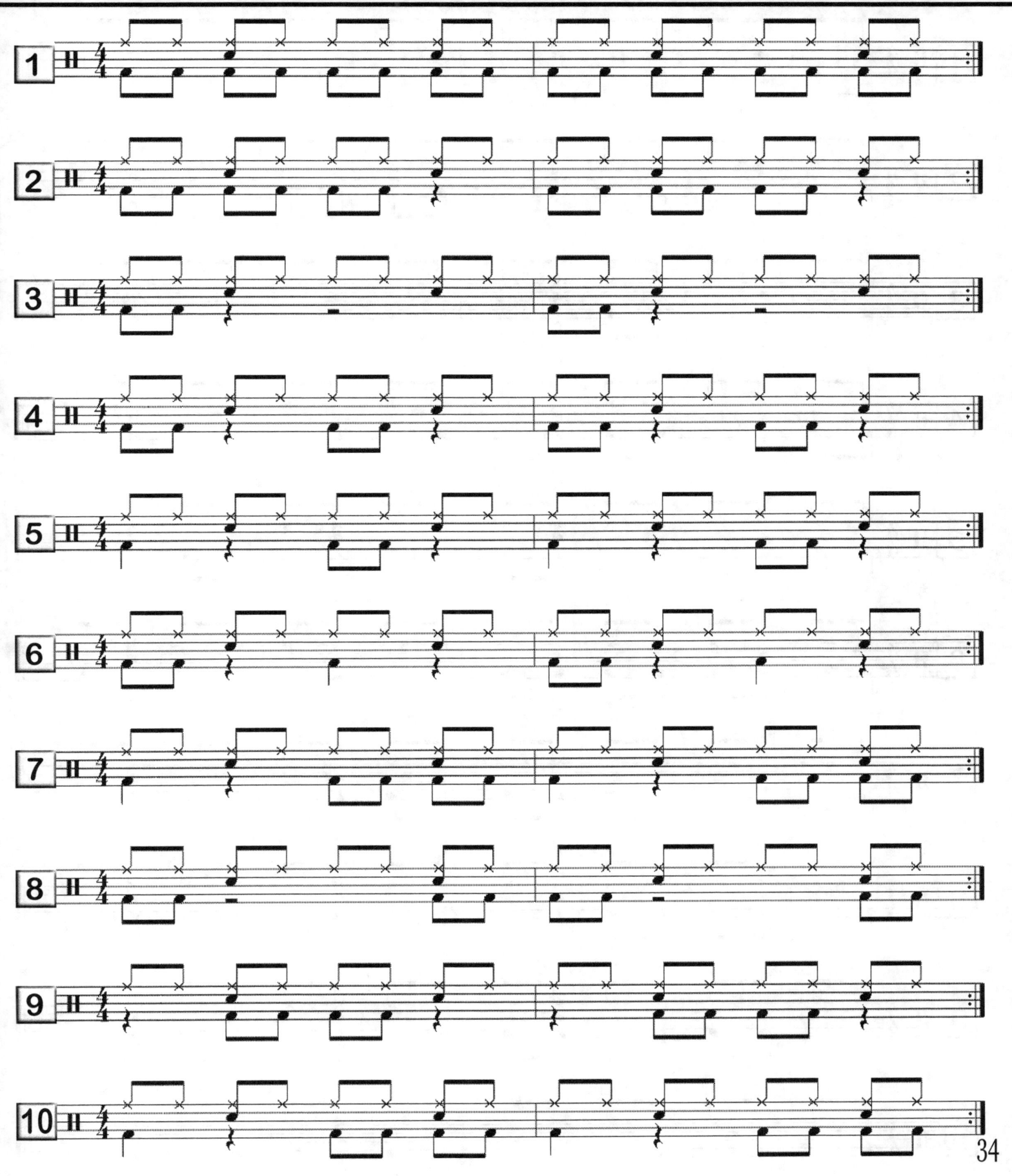

34

8th Note Drum Grooves 3

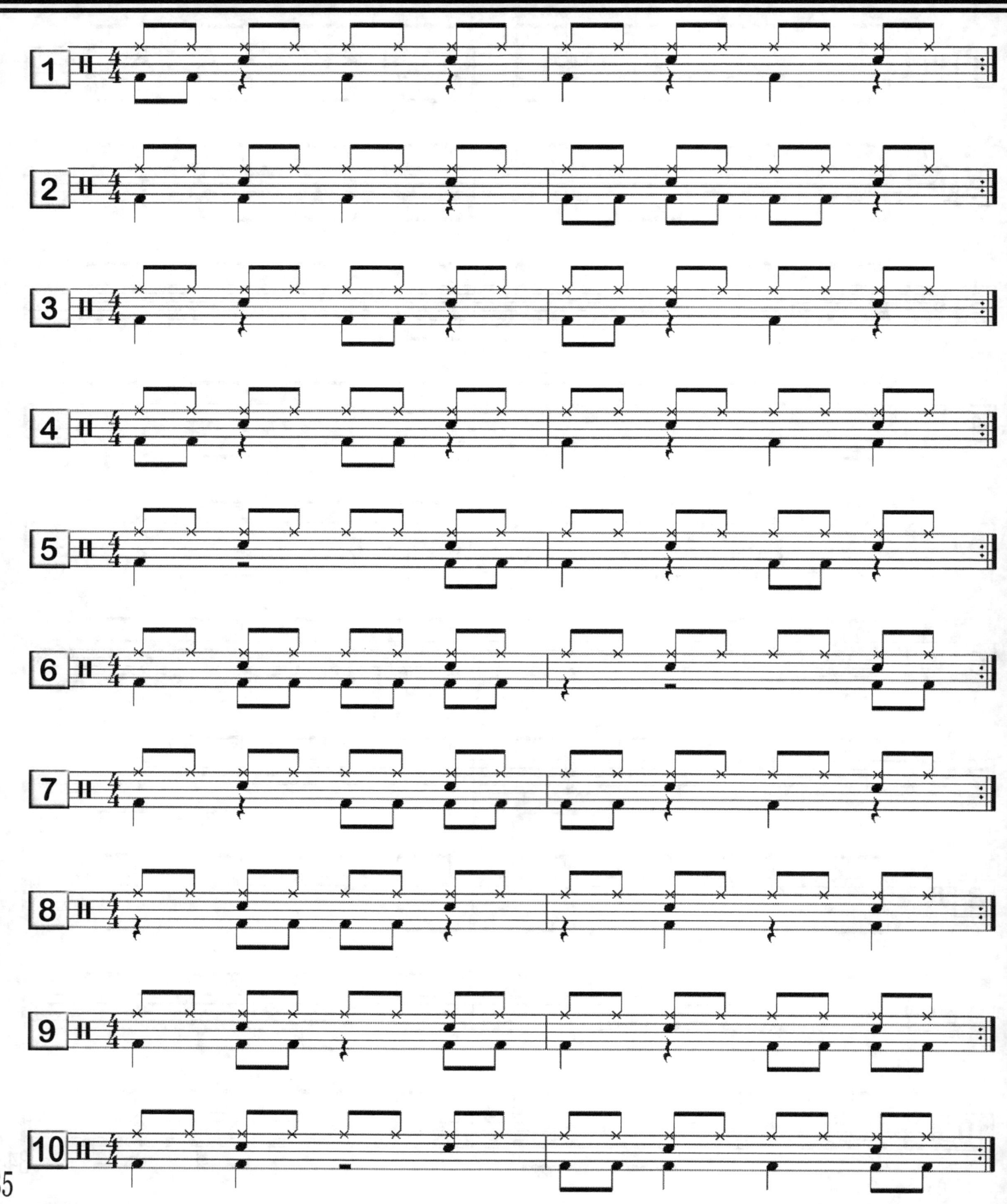

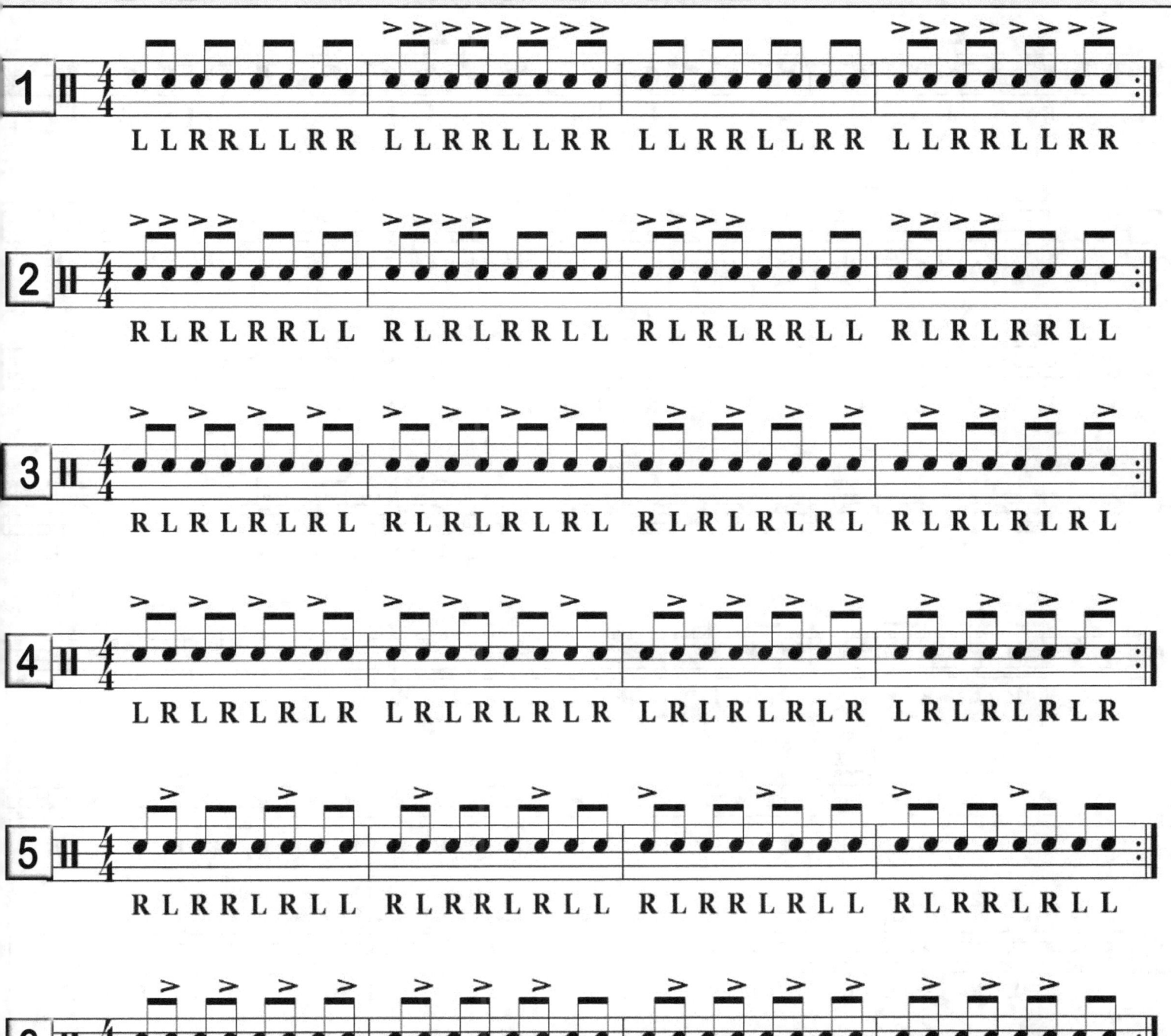

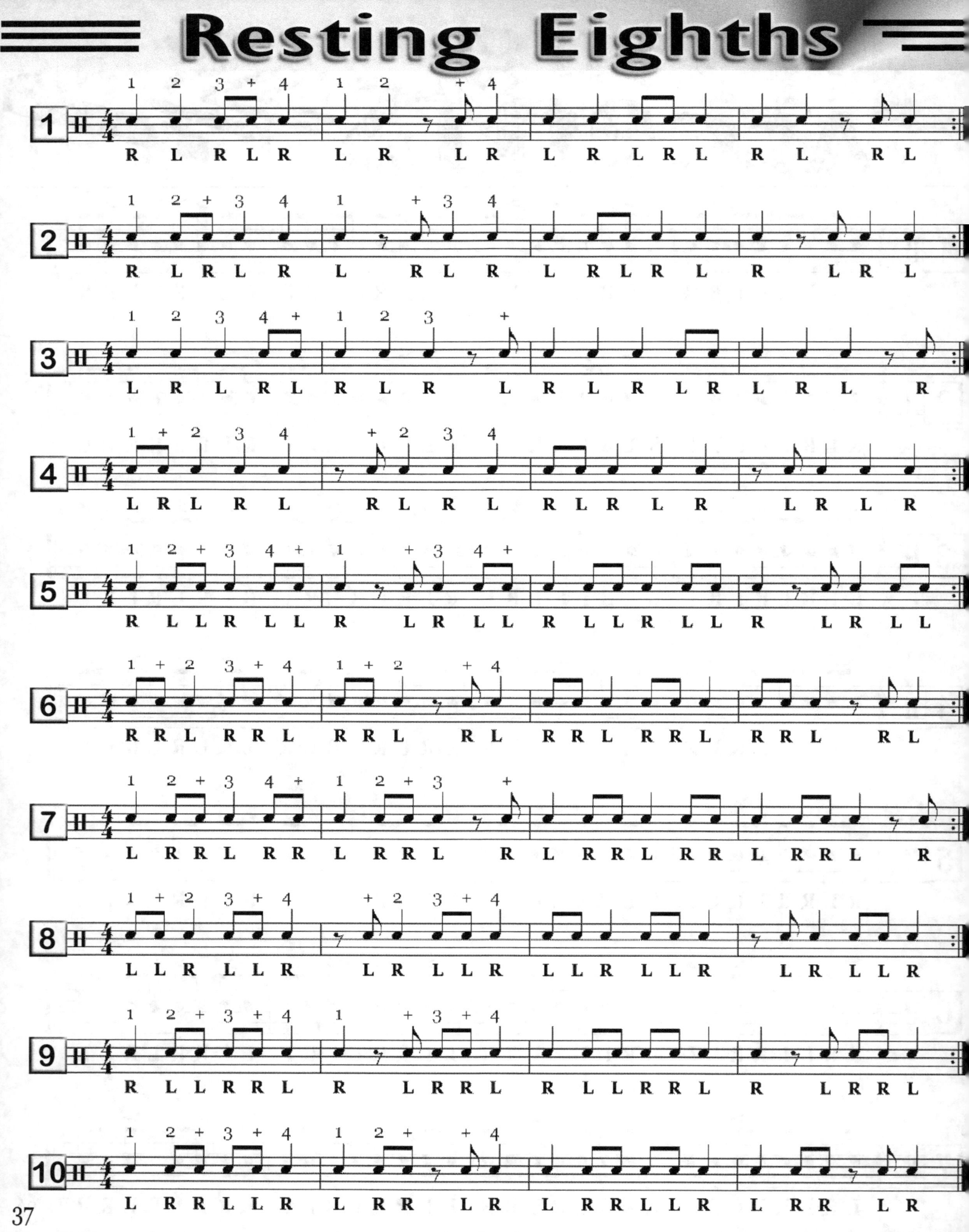

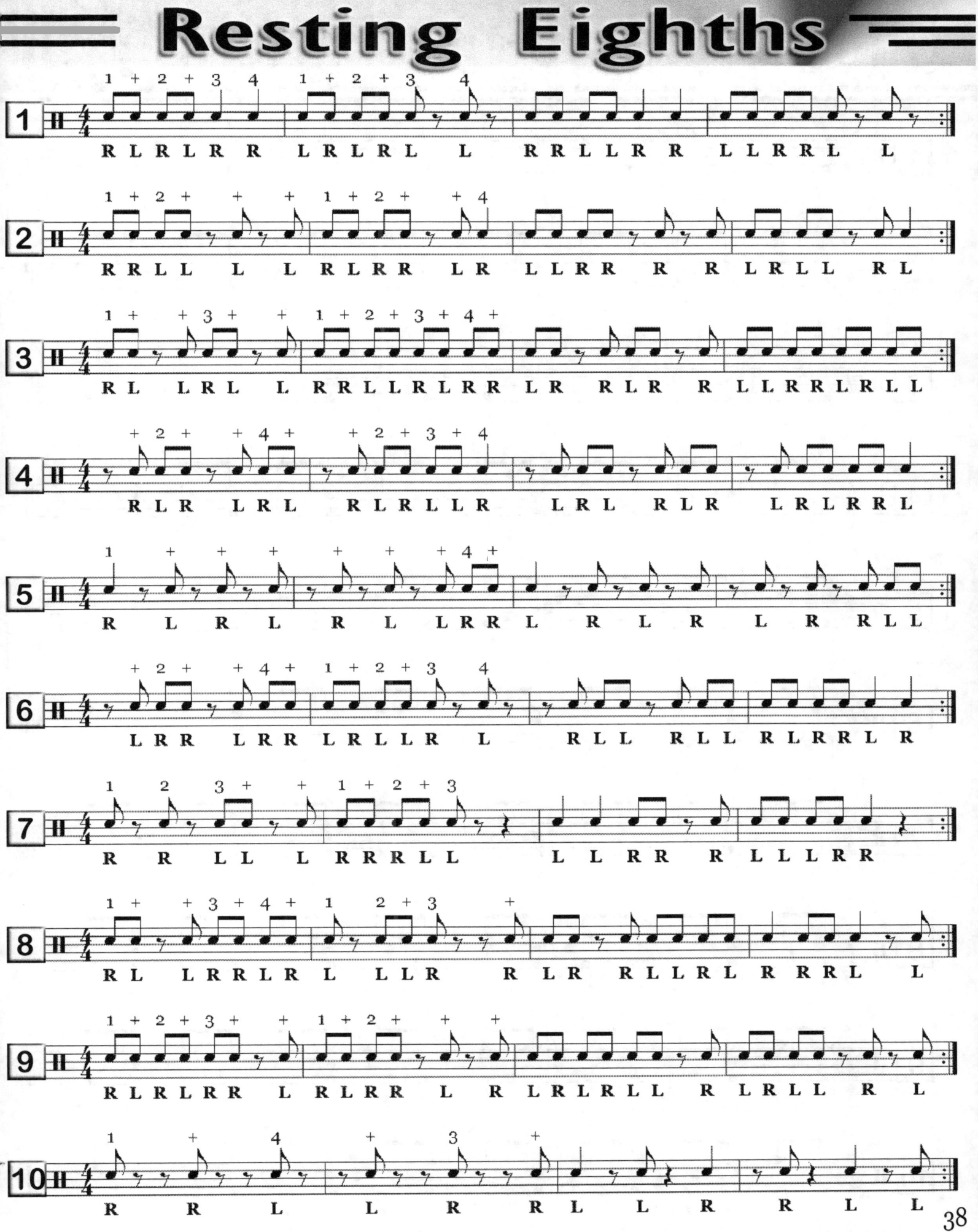

Offbeat Bass Drum Patterns 1

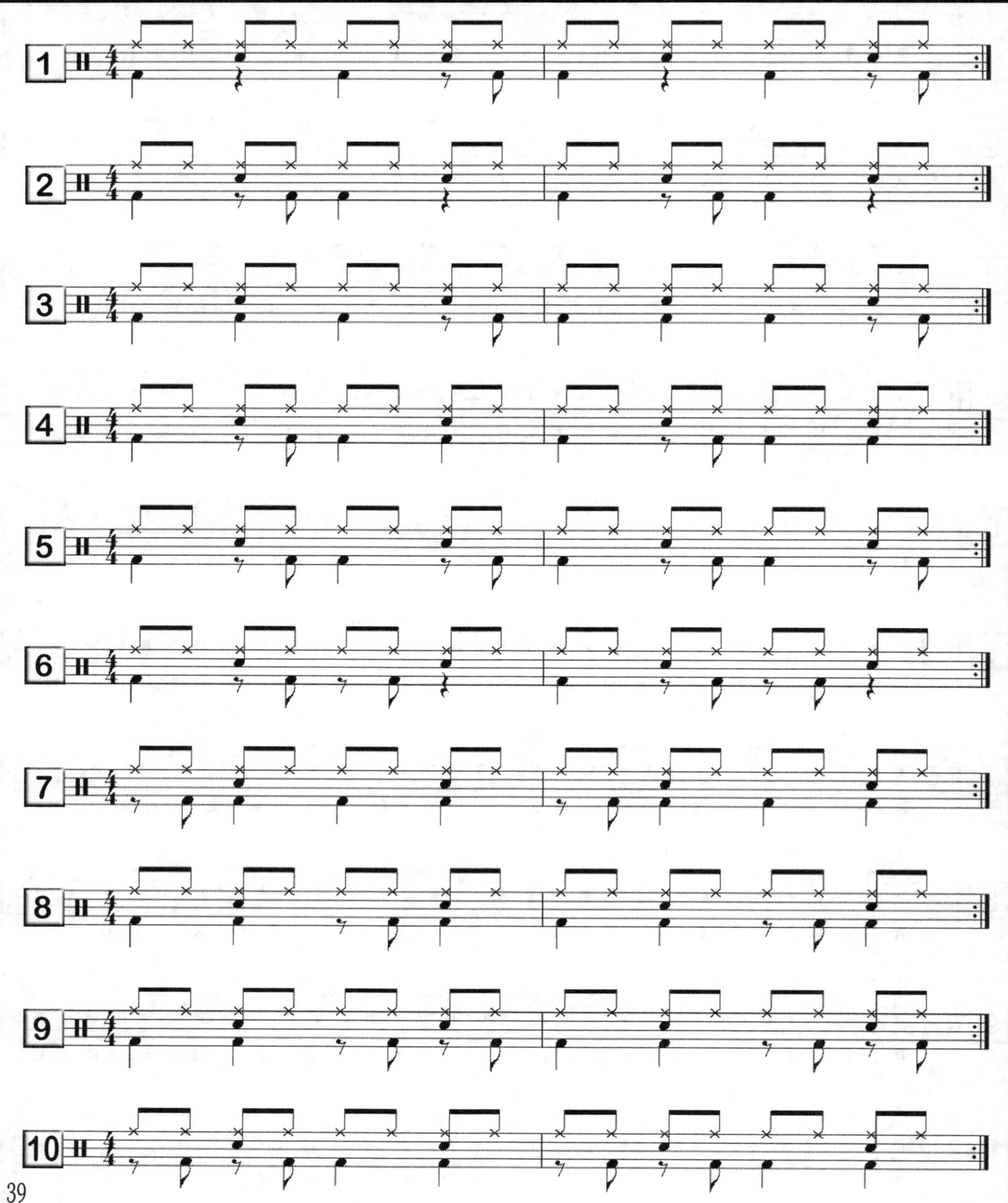

Offbeat Bass Drum Patterns 2

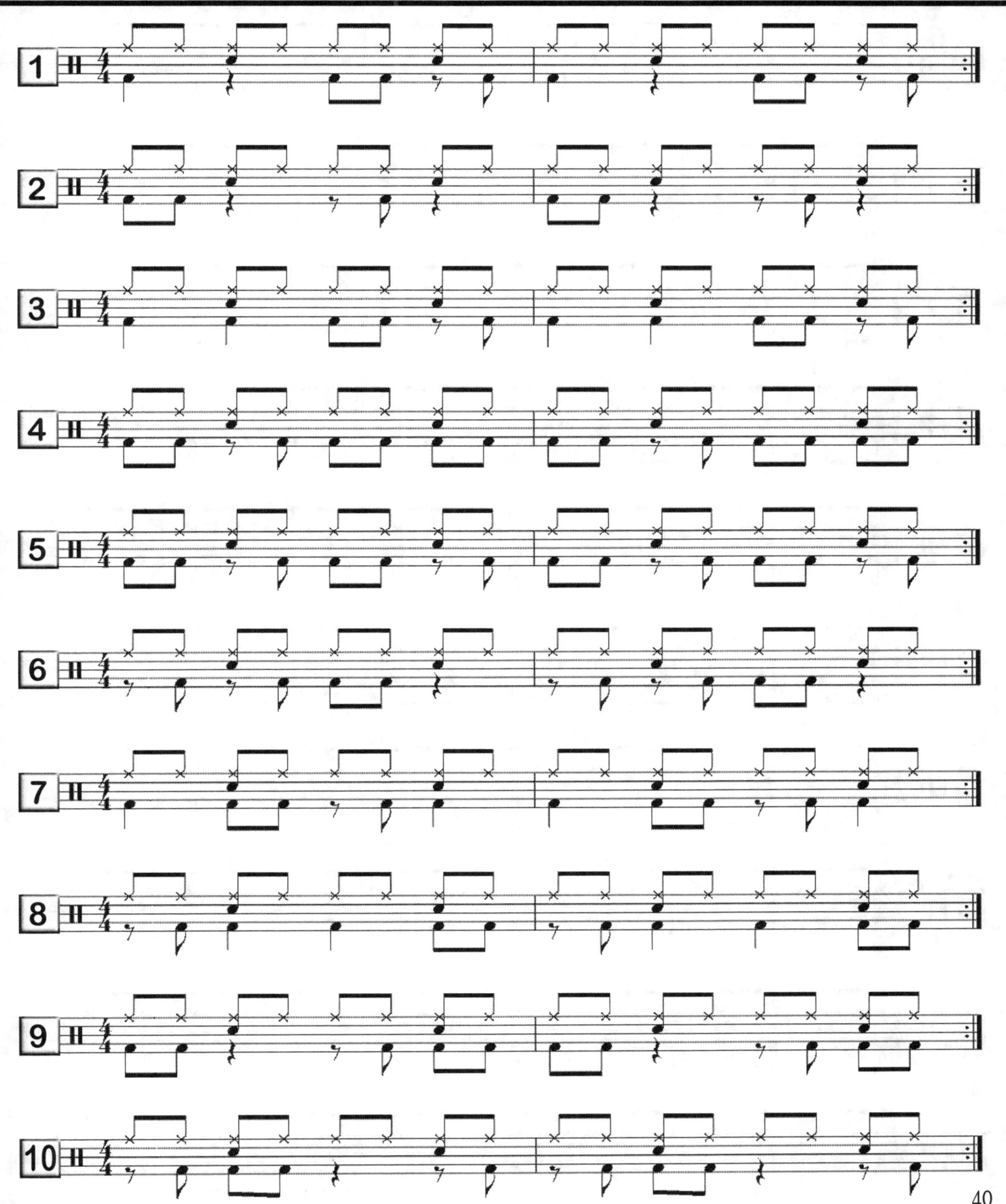

Offbeat Bass Drum Patterns 3

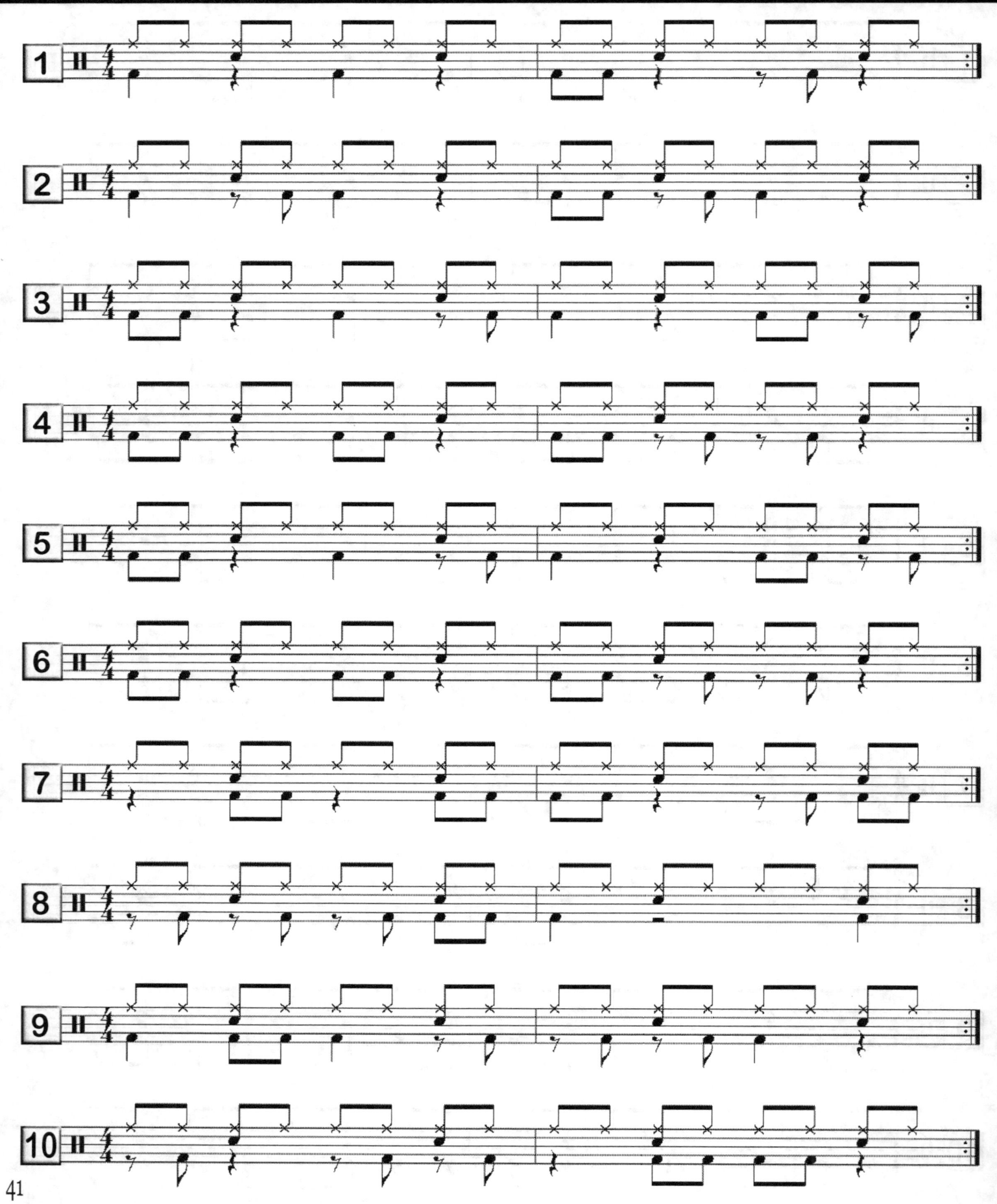

How the Rack Toms, Floor Toms and Crash Cymbal are written on the Staff

You're now able use all four limbs by reading the Kick, Snare, Hi-Hat, and Ride. Notice that these four maintain their place on the Staff. Your now ready to play the Rack Toms, Floor Tom and Crash Cymbal which also have their very own specific place on the Staff.

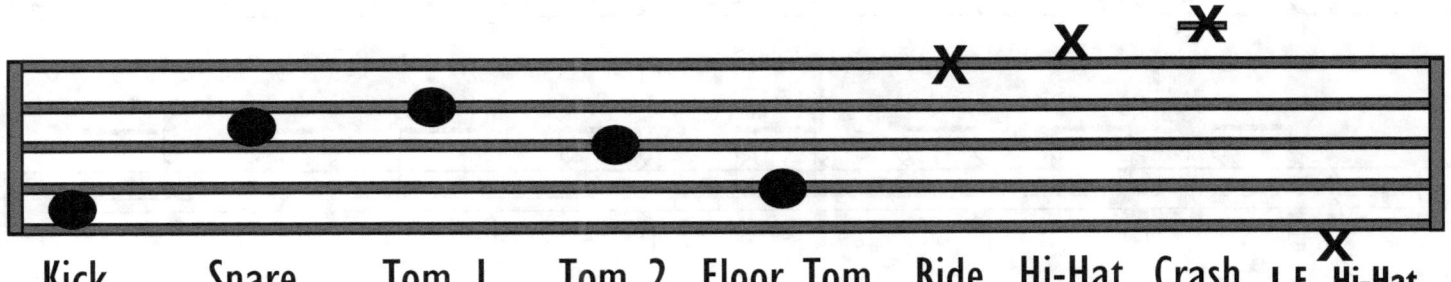

Kick Snare Tom 1 Tom 2 Floor Tom Ride Hi-Hat Crash L.F. Hi-Hat

There is no right or wrong way to organize your drumset. As you grow and become a better drummer, you may change things about your set. You might watch another drummer online and or in concert and see how their drumset configuration might inspire you to try something new with your set up.

It maybe you have purchased a new cymbal or another tom and you might set things in new places so that you might reach them a little easier and or because it looks cool. For whatever Reason your drumset has many voices and it is sometimes Difficult to notate every single piece of equipment that comprises it.

So the staff will give you a good idea of what is to be played but if you have 7 crash cymbals pick the one you want to hit and hit it. The same goes for the rest of the drumset as well. The music will give you the correct rhythms just pick and choose what works best for the music. Keep in mind that it is all about being melodic and tasteful. If it works for you then that is what helps contribute to your identity behind the drumset.

8th Notes on the Snare Drum

Adding 8th Notes on the Snare Drum can create a whole library of patterns to play.

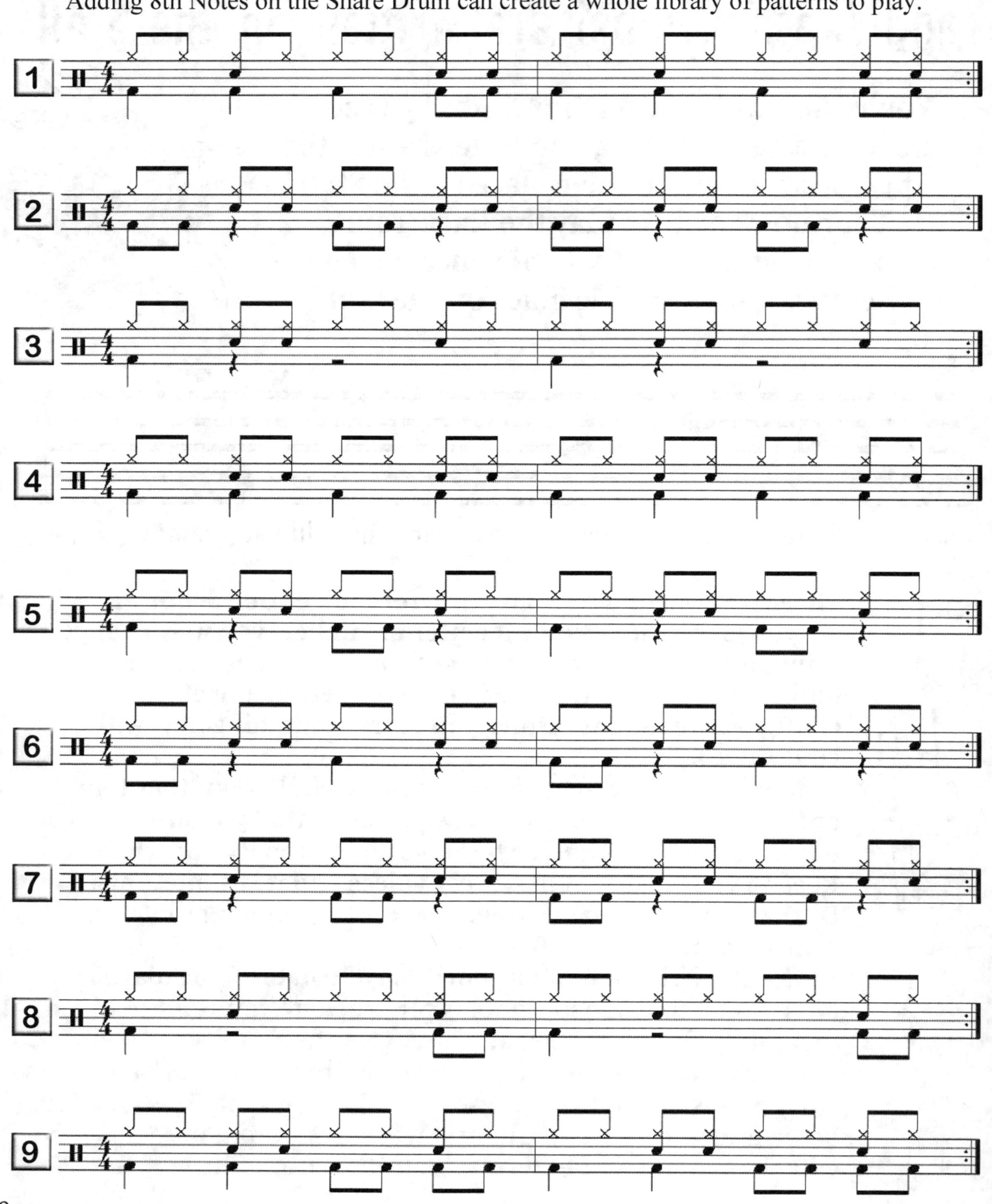

Straight Four on the Snare Drum

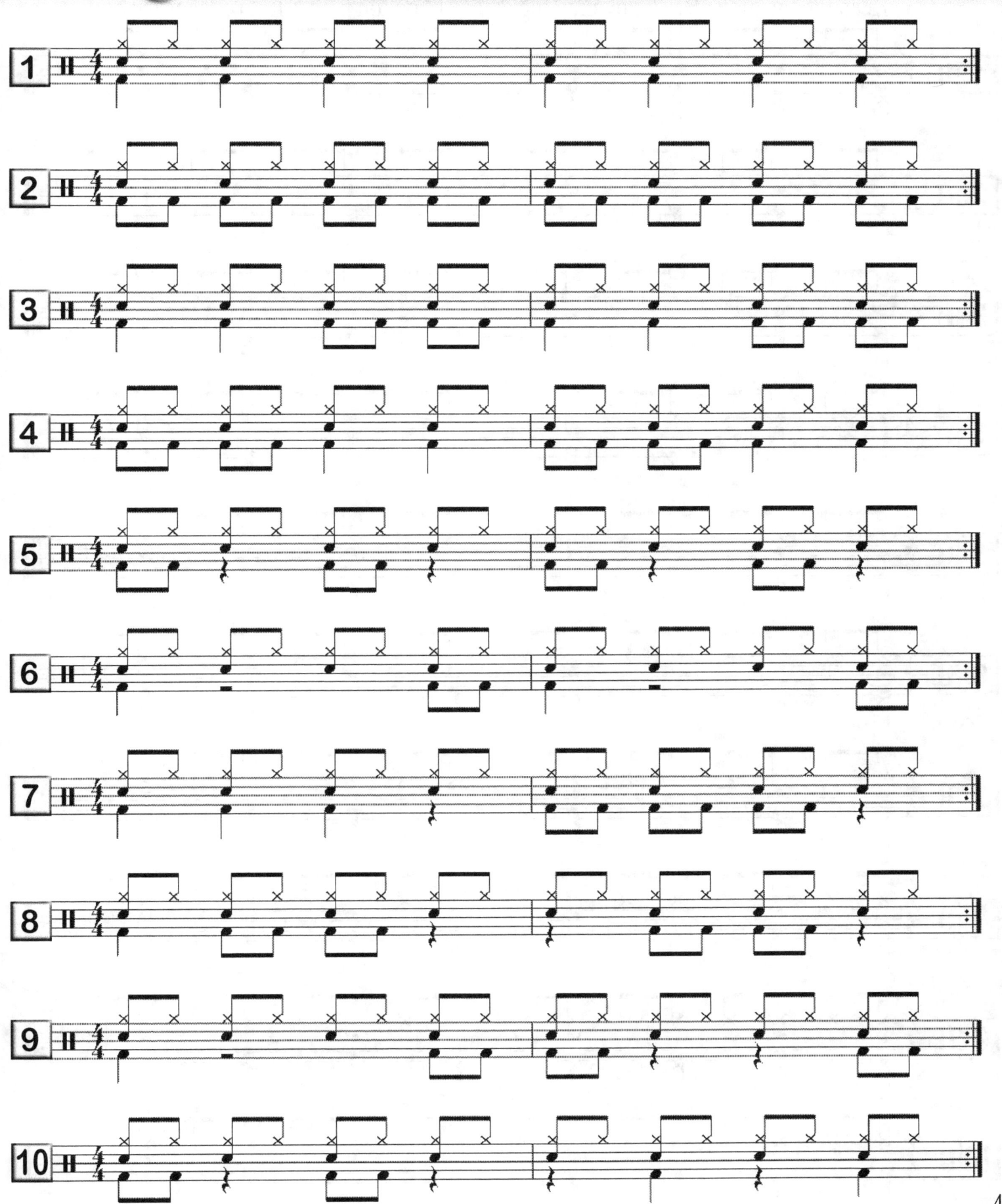

Keeping Time with the Left Foot

Keep time with the Hi-Hat by pressing the Left Foot on the Hi-Hat pedal every beat.

Four Beat Fills

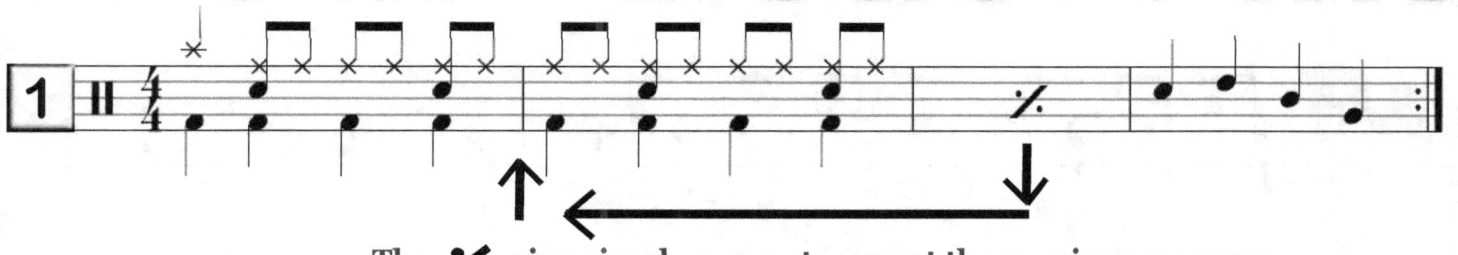

The ✗ sign simply means to repeat the previous measure.

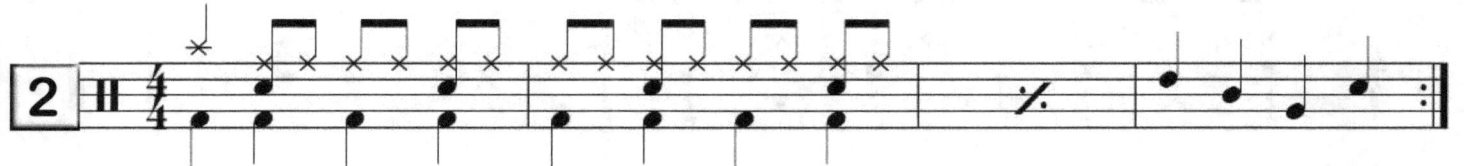

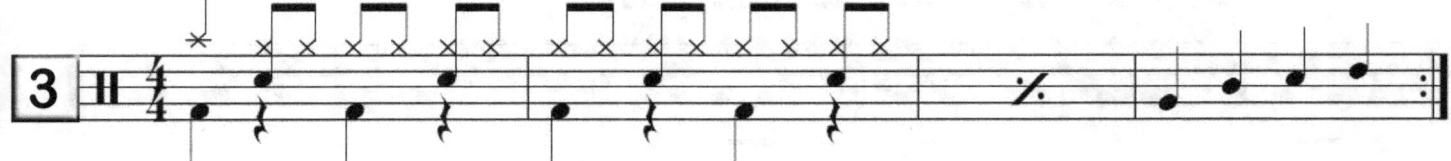

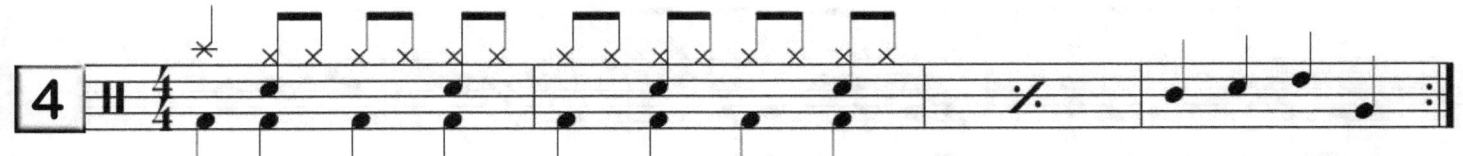

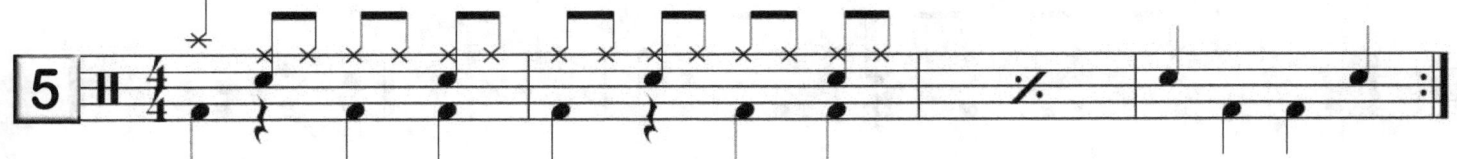

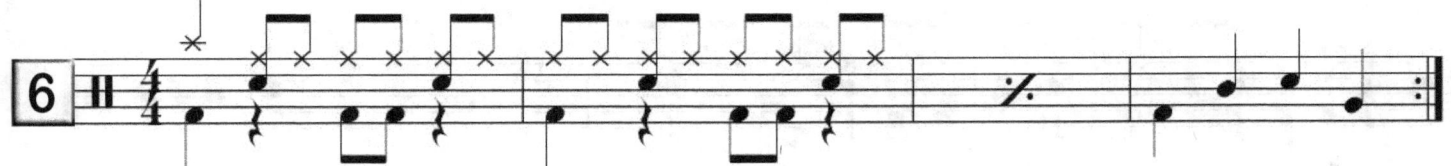

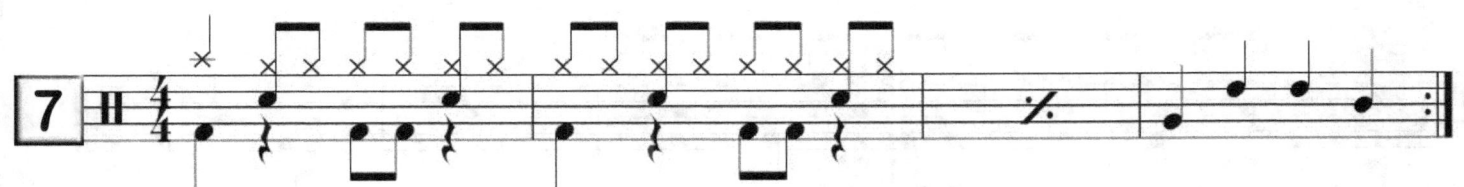

Four Beat Fills 2

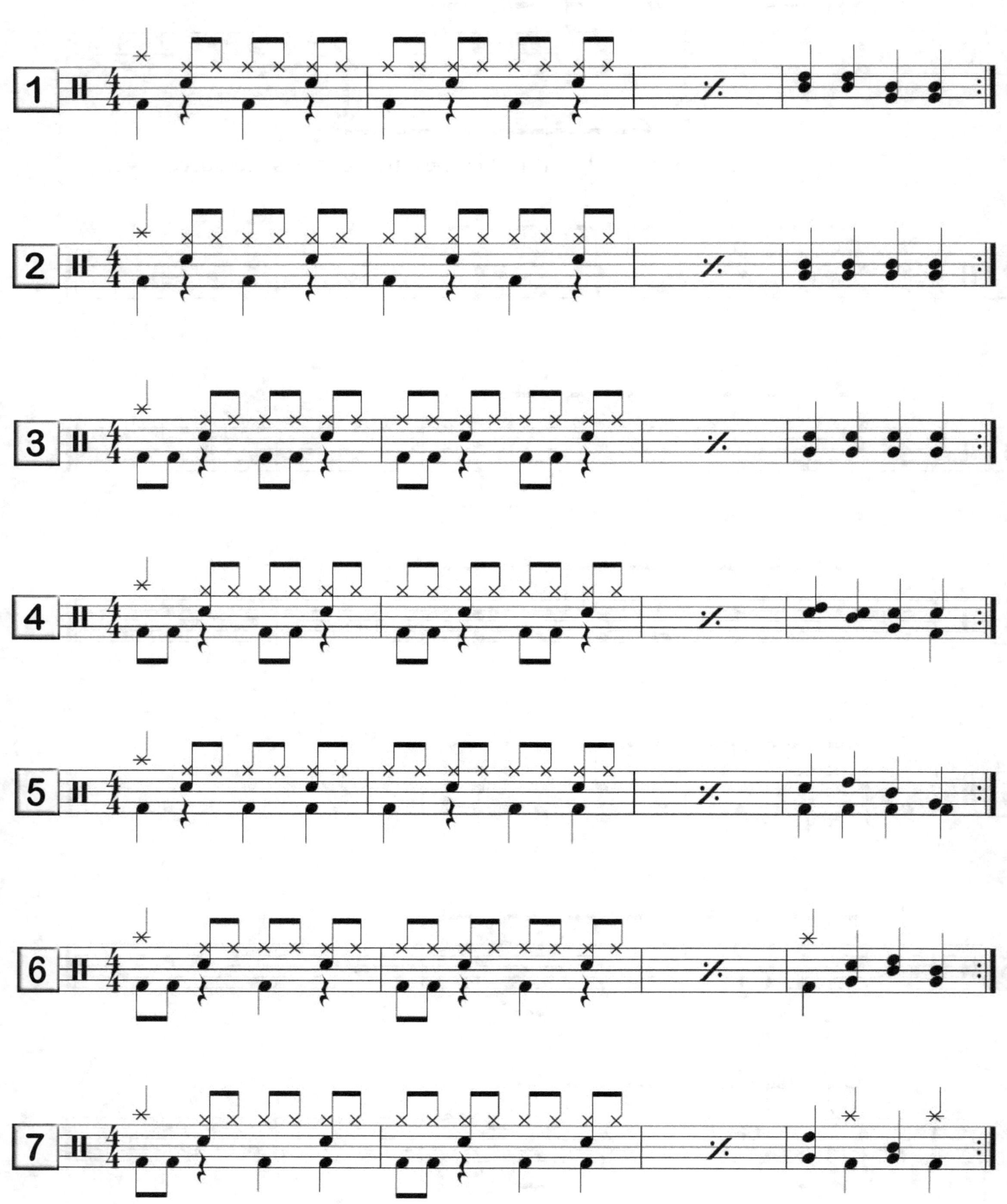

Create Your Own BEAT!

When learning a language it is important that you not only learn how to speak it but also be able to write it. When you learn how to write something out you will have a better understanding of it. So with these exercises I want you to write out your very own beats using any part of the drumset that you wish to include. Be as creative as you want. If you need ideas look at some of the previous exercises to help you get started

1.

2.

3.

4.

5.

6.

Create Your Own FILL!

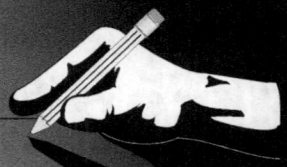

Creating your own drum fills is a great way to express yourself behind the drumset. Use all that you have learned up to this point. Remember that being accurate is everything when you are putting something down on paper. From placing the note at the right place on the staff, to using the correct rest to get the exact feel you want out of your drum fill. Make each fill last 4 beats long and have fun with this.

Make It Count

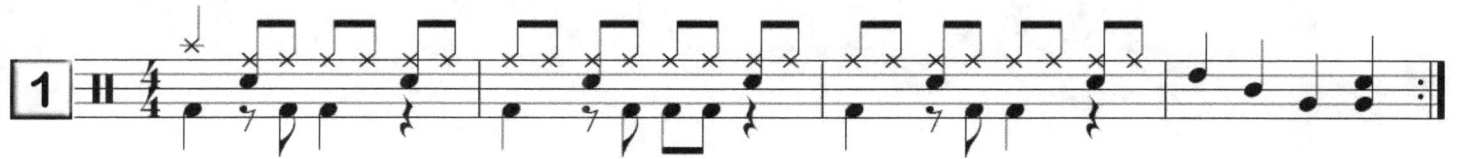
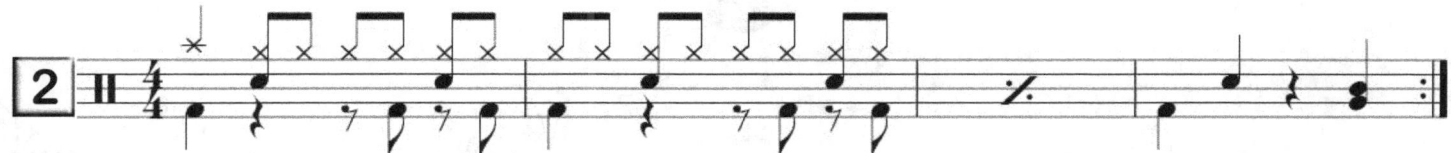
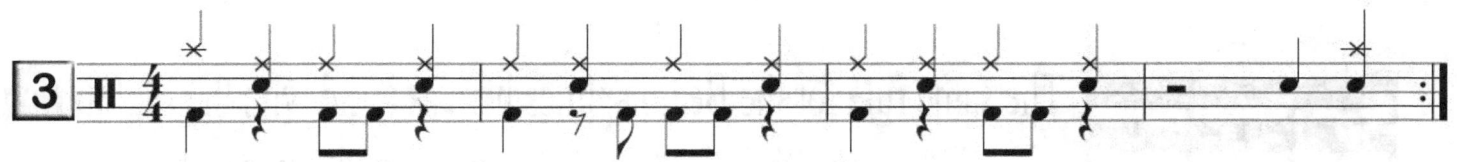
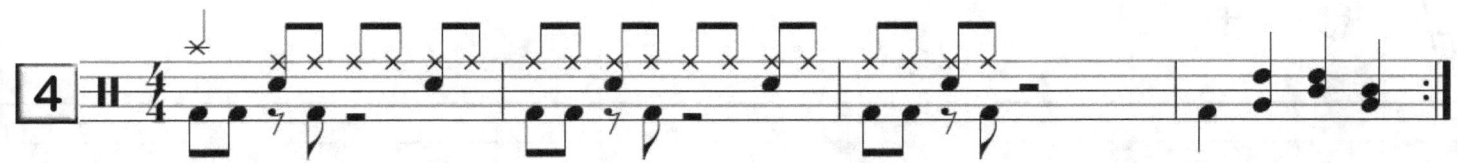
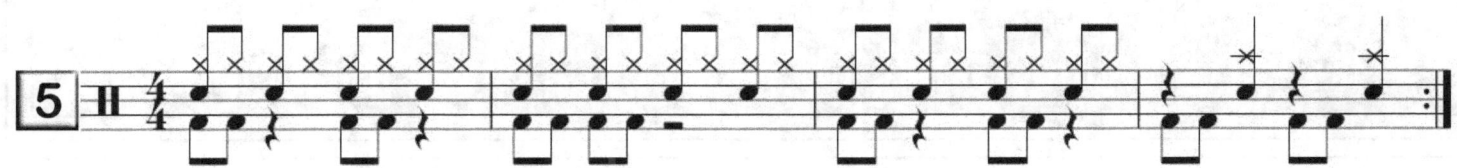
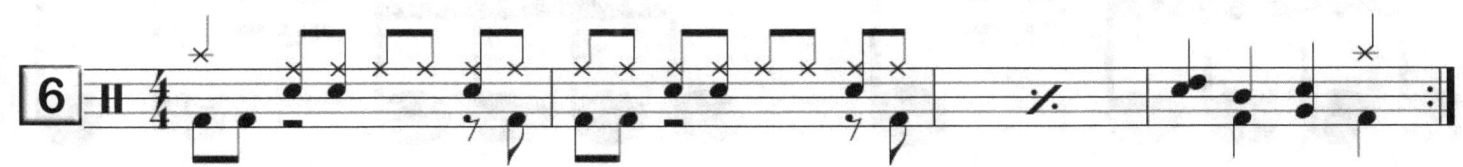

LEARNING HOW TO PLAY SIXTEENTH NOTES

This is called a Sixteenth Note → ♬ Instead of one Flag like the Eighth Note the Sixteenth Note has TWO Flags.

This is the Sixteenth Note Rest → 𝄿 ← Very similar to the Eighth Note Rest The Sixteenth Note Rest has 2 circles.

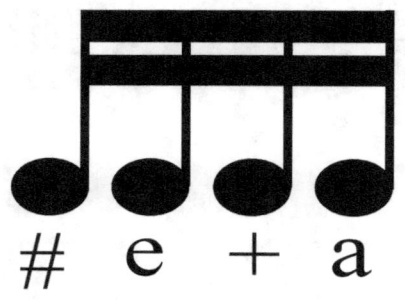

\# e + a

The same rule for the Beam applies here as it did with the Eighth Note. **When multiple Sixteenth Notes are written side by side you will see them connected by TWO Beams.**

1. It takes 4 Sixteenth Notes to equal the value of 1 Quarter Note.
2. It takes 4 Sixteenth Notes to equal the value of 2 Eighth Notes.
To help you understand this check out the example below.

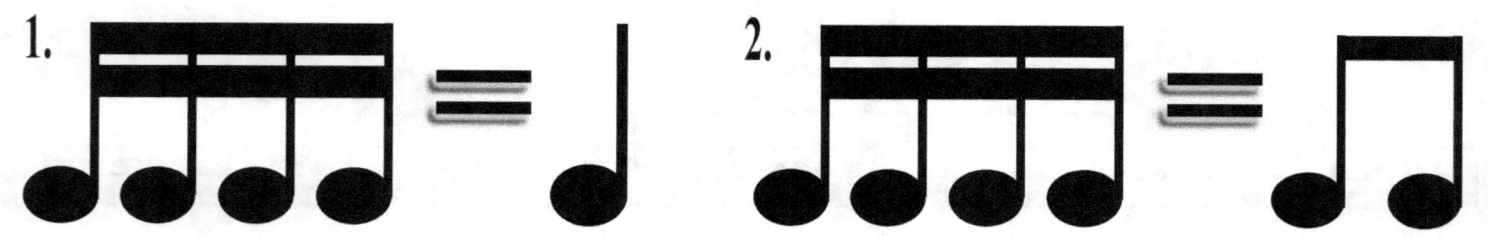

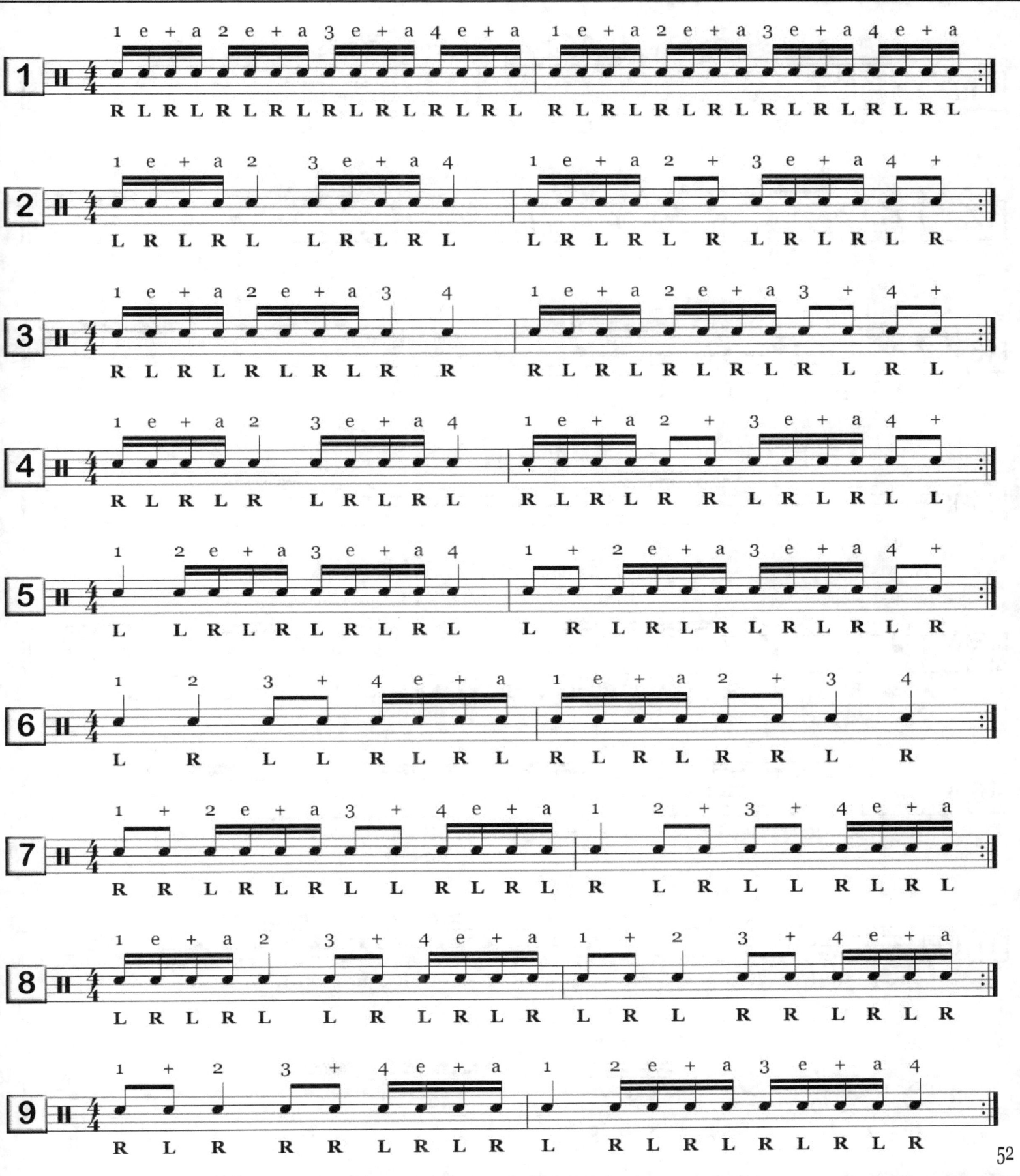

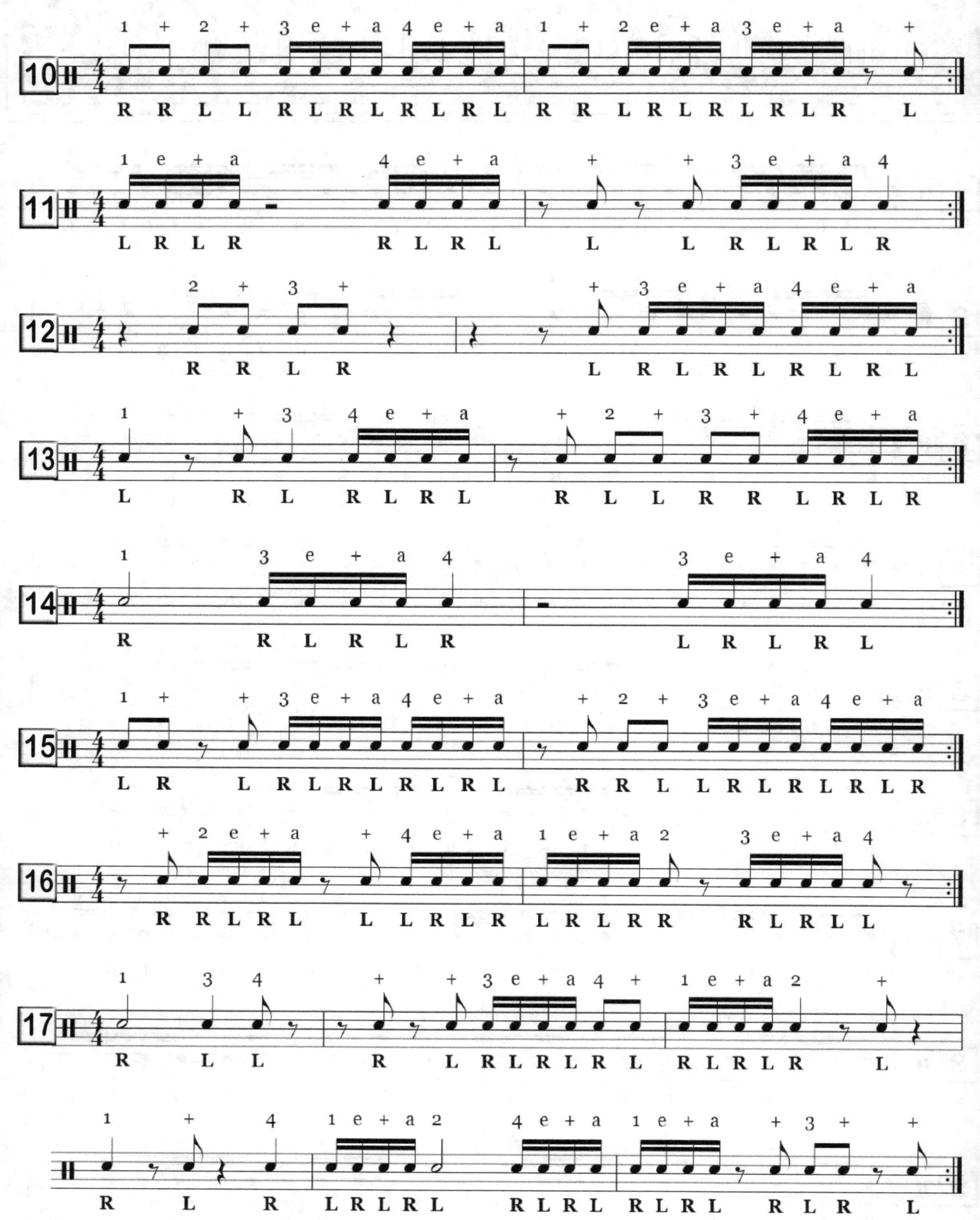

Flying 16's

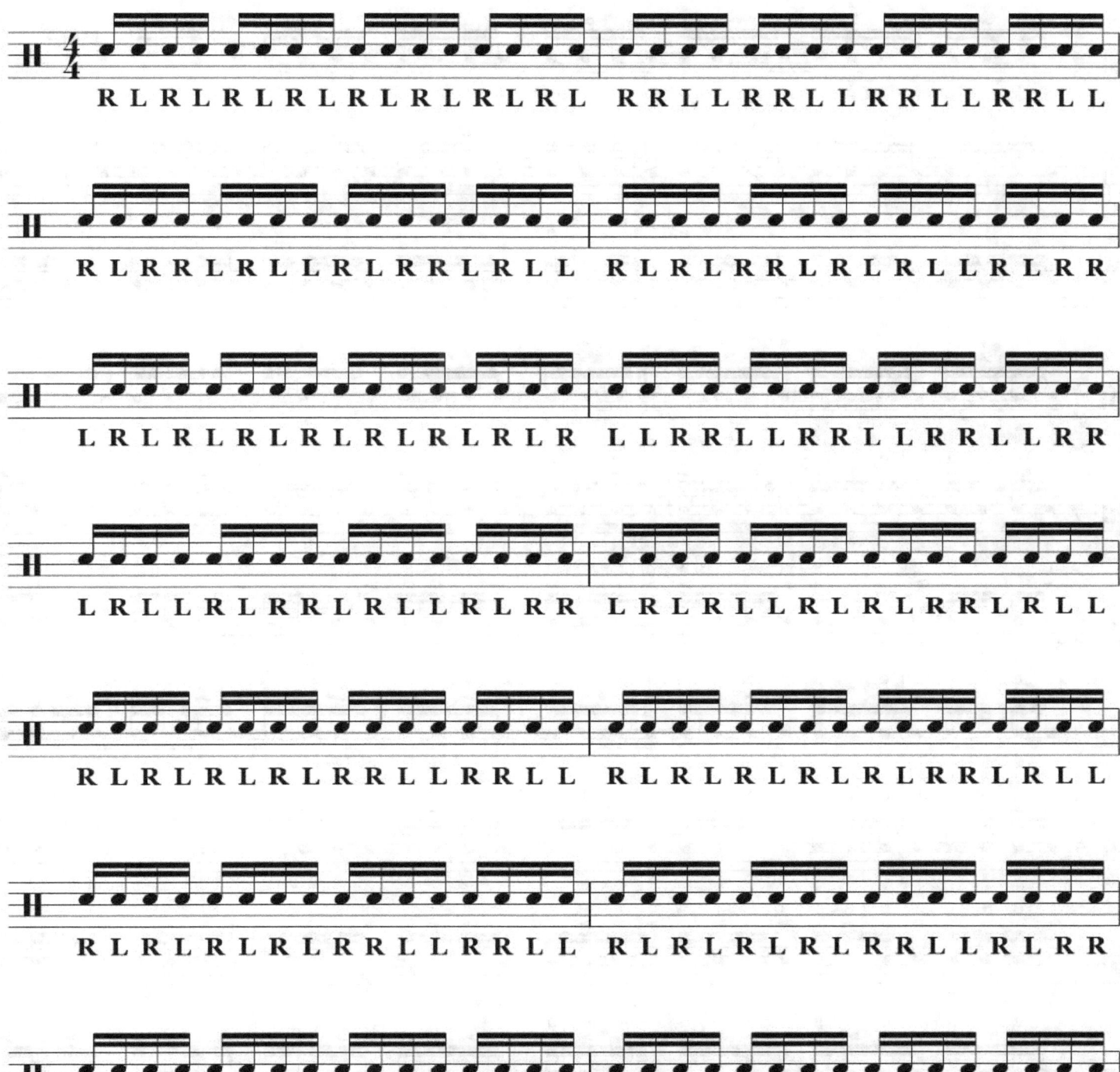

Accenting Around the Sixteenth Note

16th Note Ride Patterns 1

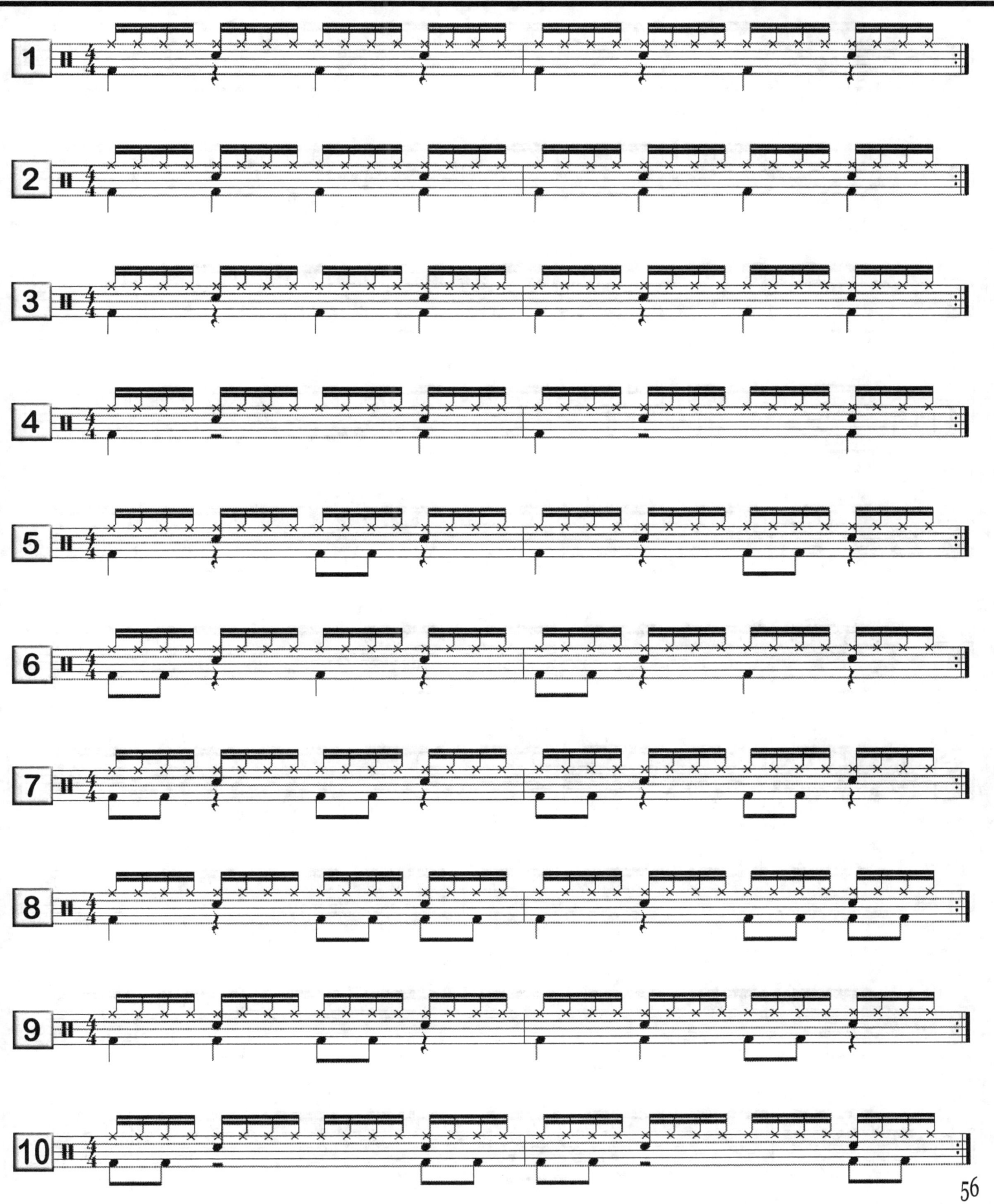

56

16th Note Ride Patterns 2

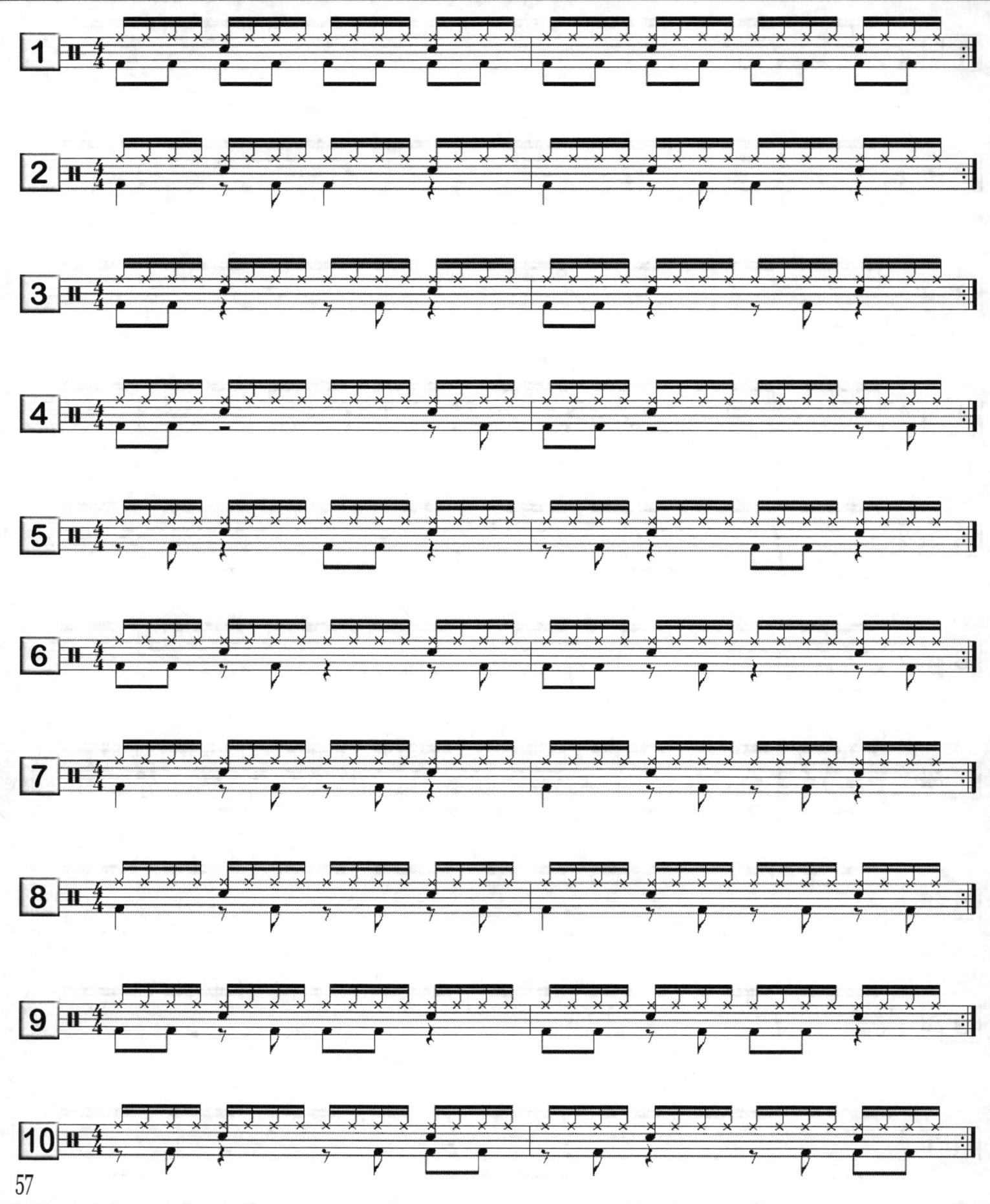

16th Note Ride Patterns 3

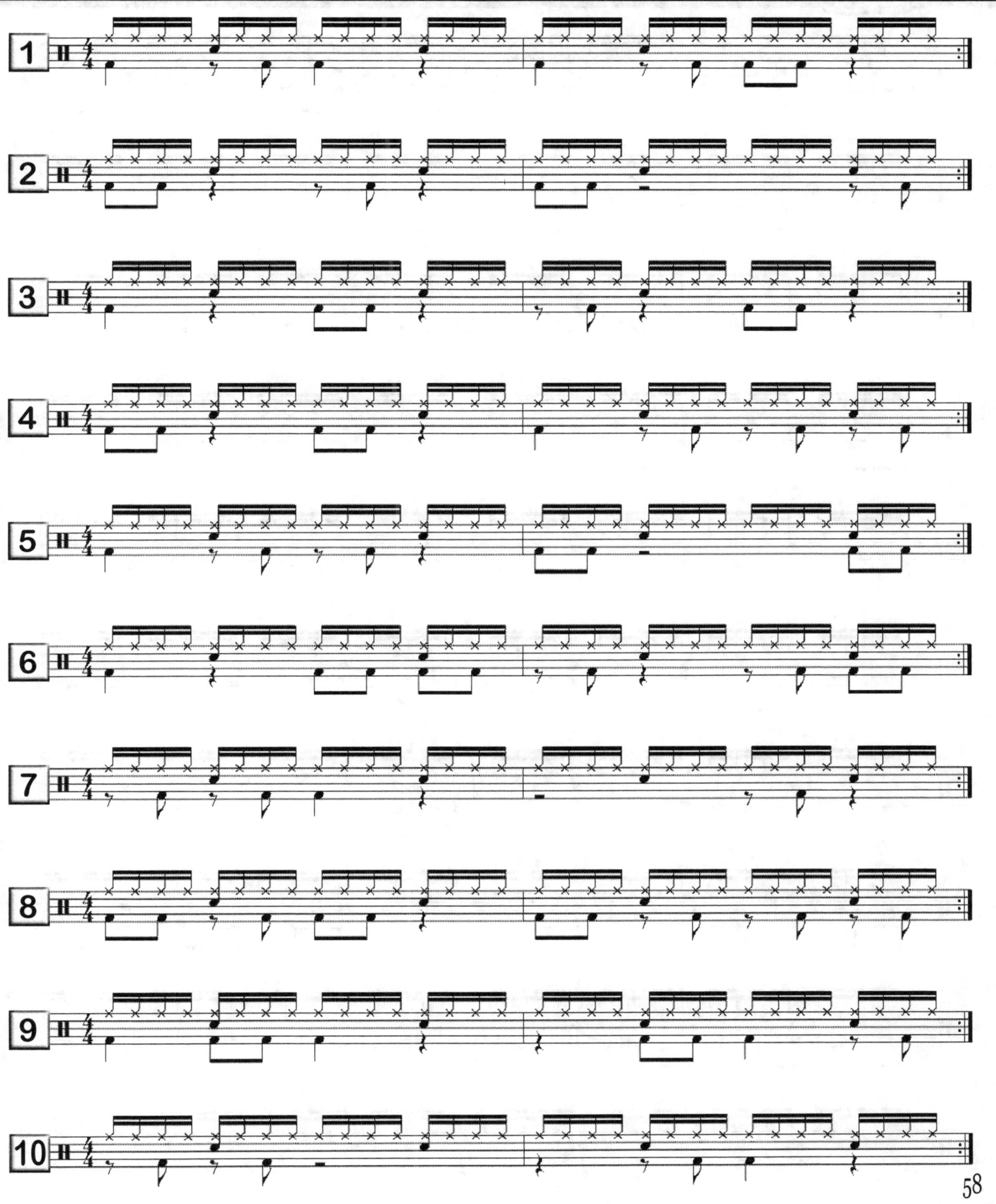

Make It Count

Alternating 16th Notes on the Hi-Hat

The way that these patterns are to be played are written above the first example. Observe how the stickings on The Hi-Hat are to be played alternating, starting with the right hand. Unlike our previous grooves the Snare drum will be played with our Right hand instead of our Left.

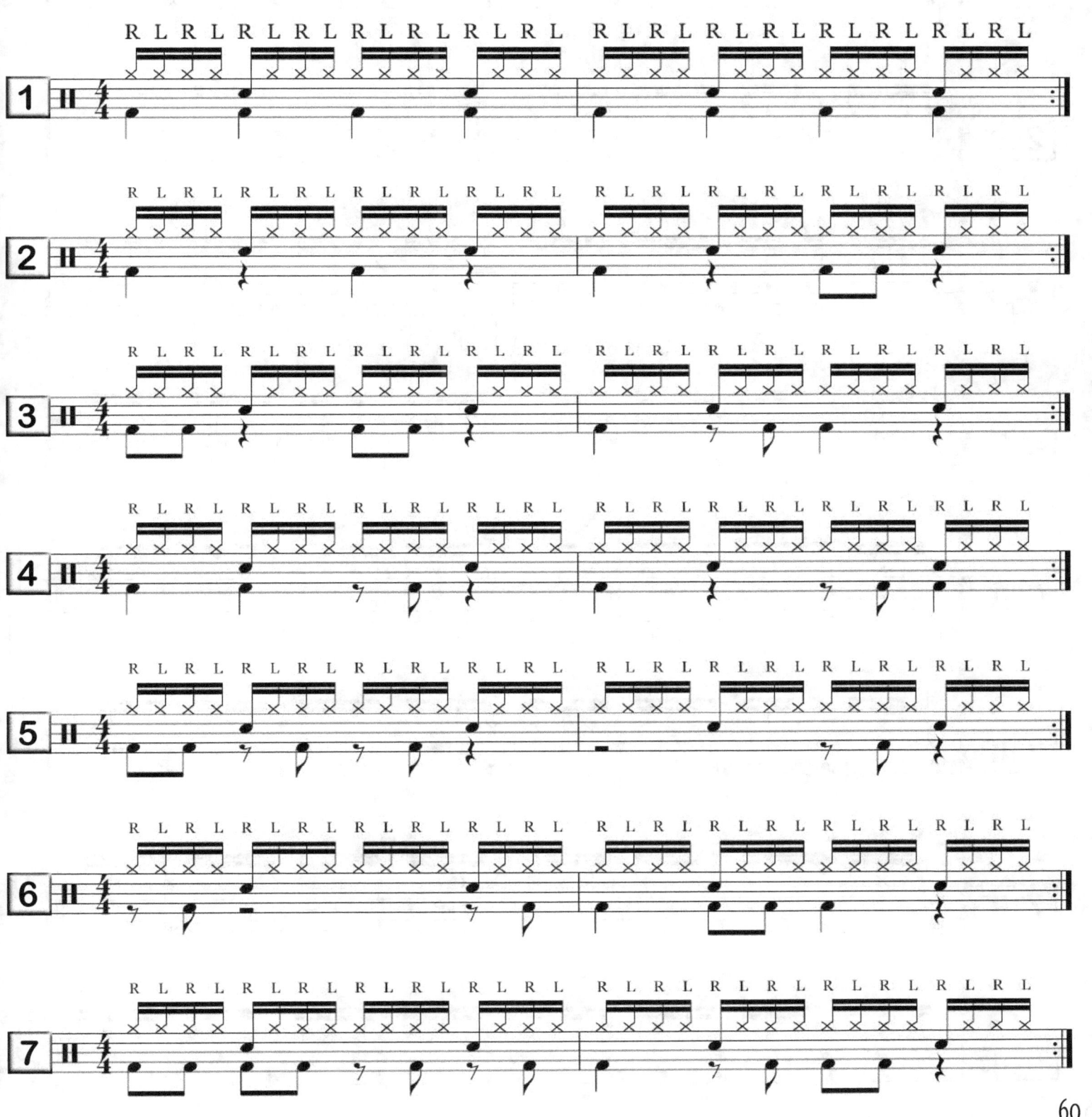

Liberating the LEFT HAND

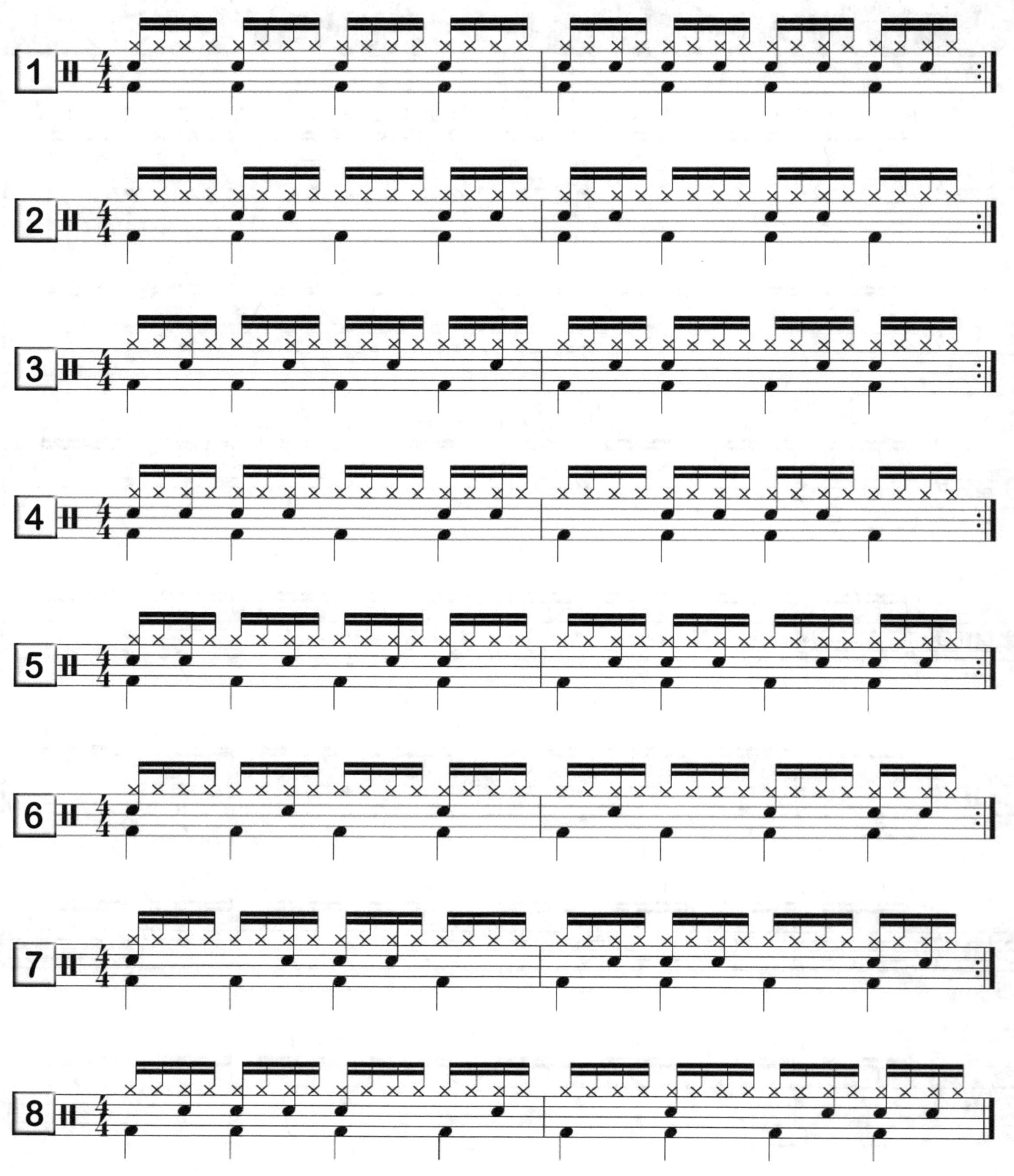

8th Note Drum Fills

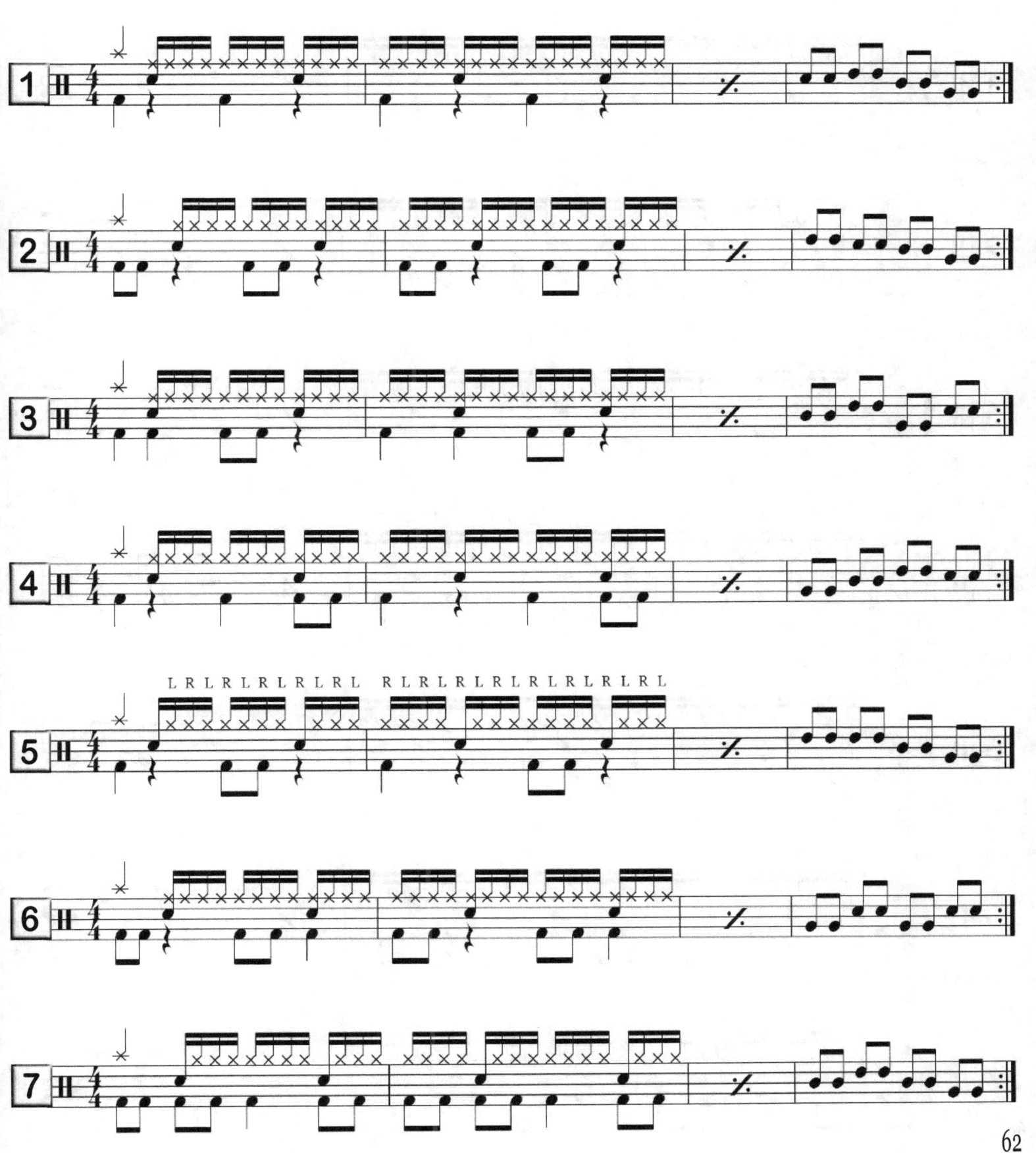

8th Note Drum Fills 2

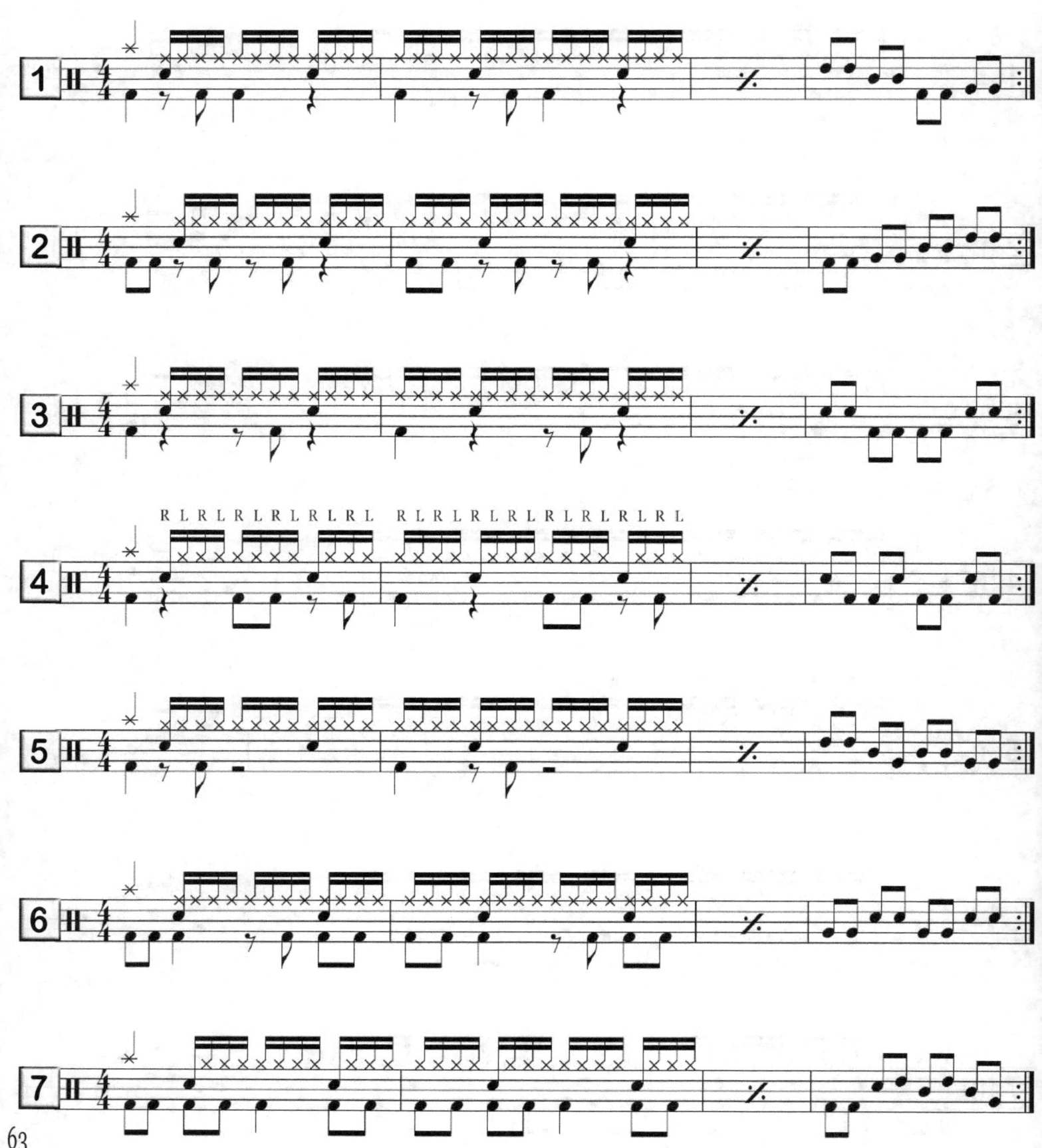

16th Note Drum Fills

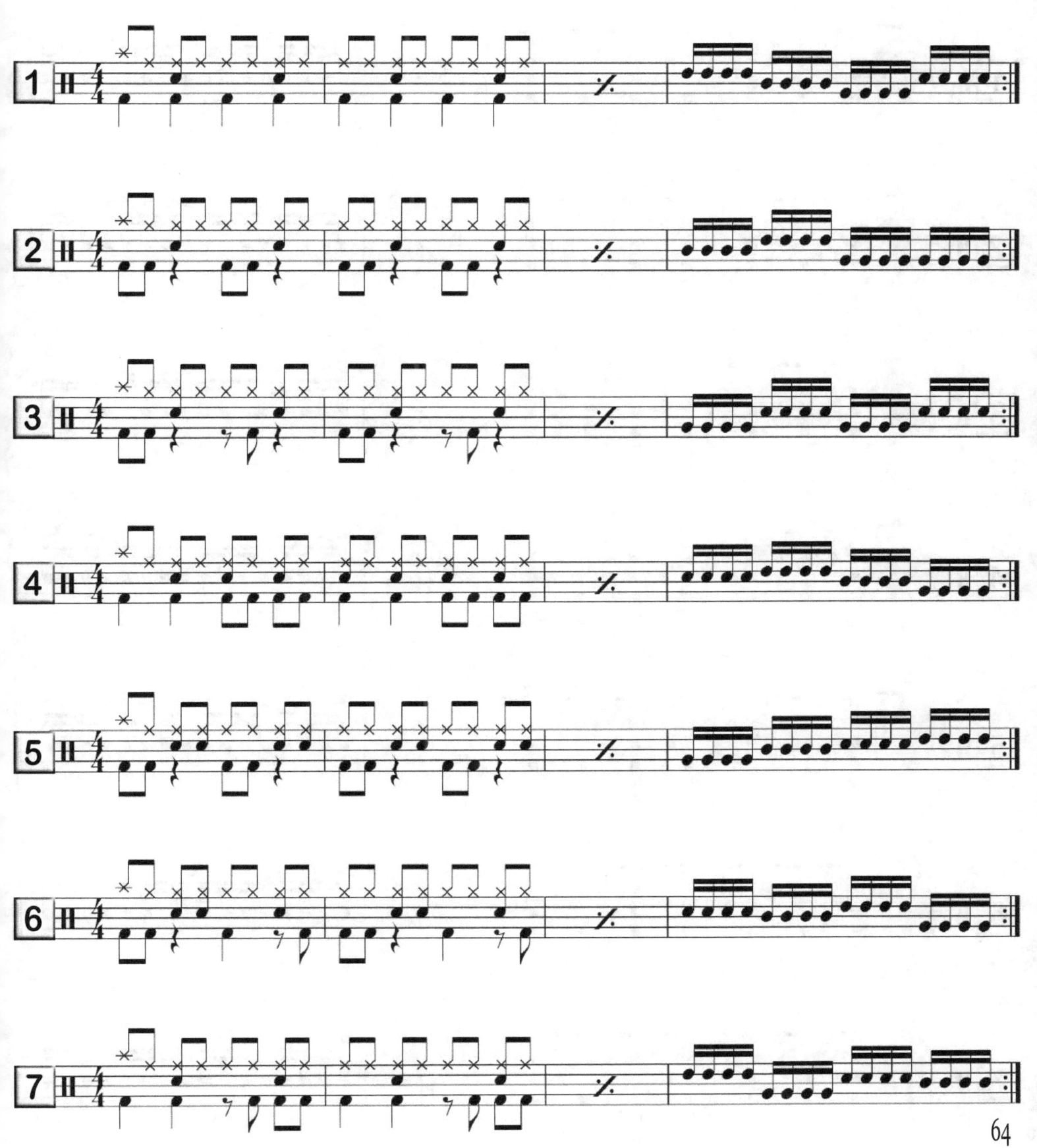

16th Note Snare Drum Fills

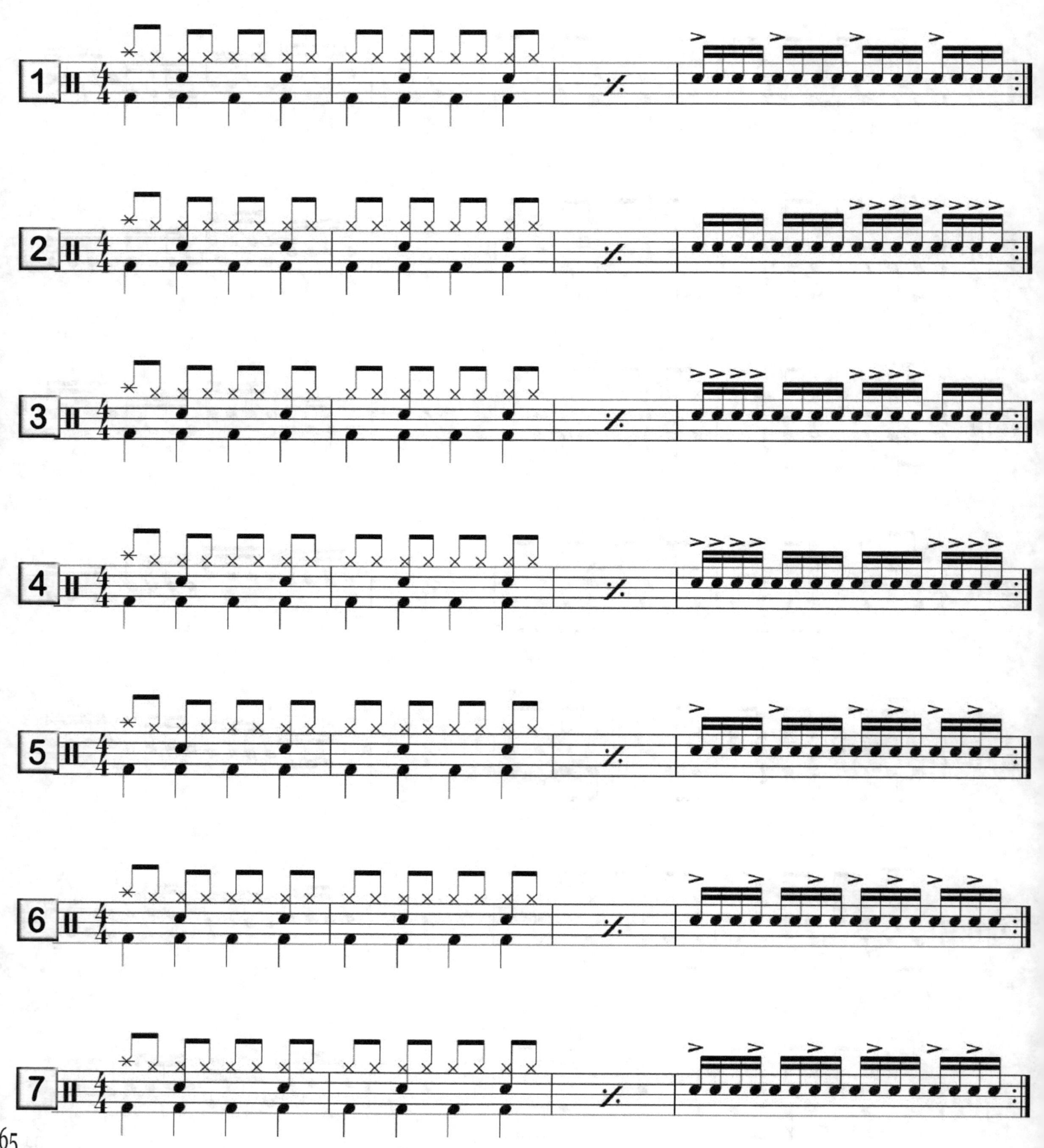

DYNAMICS

One of the first things that you should notice in any piece of music are the Dynamic Markings. The Dynamic Markings in music simply tell you how loud or soft to play in order to make use of different levels of intensity to create musical emotions.

Take a look at the Dynamic Markings below and get familiar with what they represent.

Name:	Symbol:	Effect:
pianissimo	*pp*	VERY SOFT
piano	*p*	SOFT
mezzo piano	*mp*	SOMEWHAT SOFT
mezzo forte	*mf*	MODERATELY LOUD
forte	*f*	LOUD
fortissimo	*ff*	VERY LOUD
crescendo	<	GRADUALLY LOUDER
decrescendo	>	GRADUALLY SOFTER

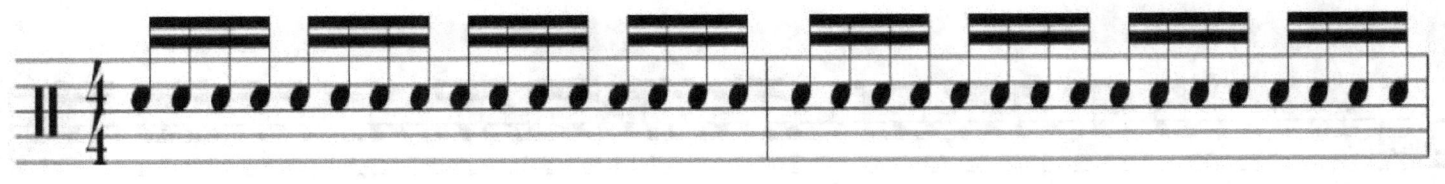

mf ← The Dynamic Markings will be found written underneath the staff.

Dynamic Stickings

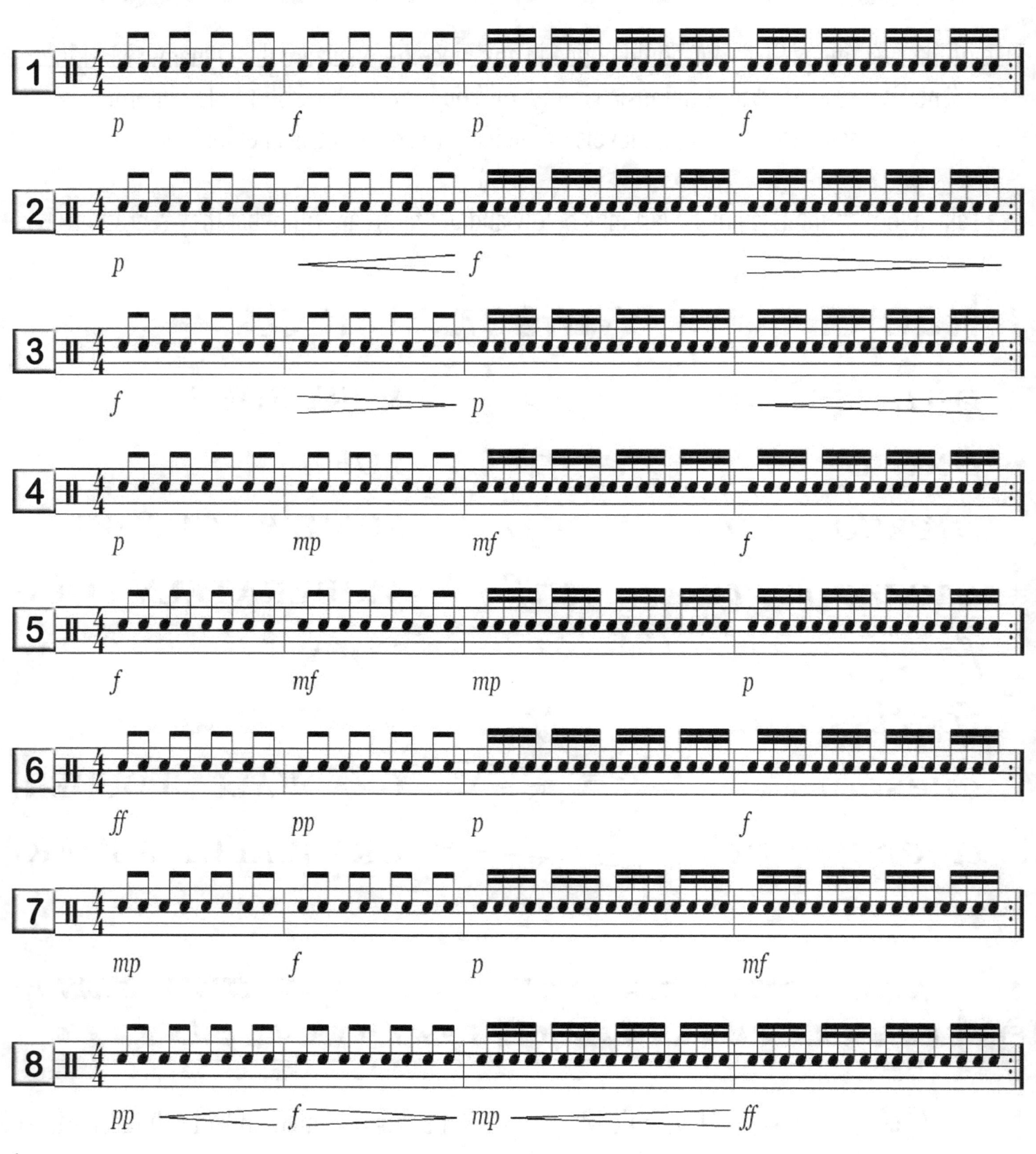

UNDERSTANDING Triplets

A Triplet is a rhythm playing three notes evenly in the space of two.

On example **A.** compare the Quarter Note Triplets written at the top of the staff to the Quarter Notes that are on the bottom. The Quarter Note Triplets sometimes have a bracket enclosing the Triplet but it will always have the number 3 written above the notes to indicate that the notes below it have a triplet feel.

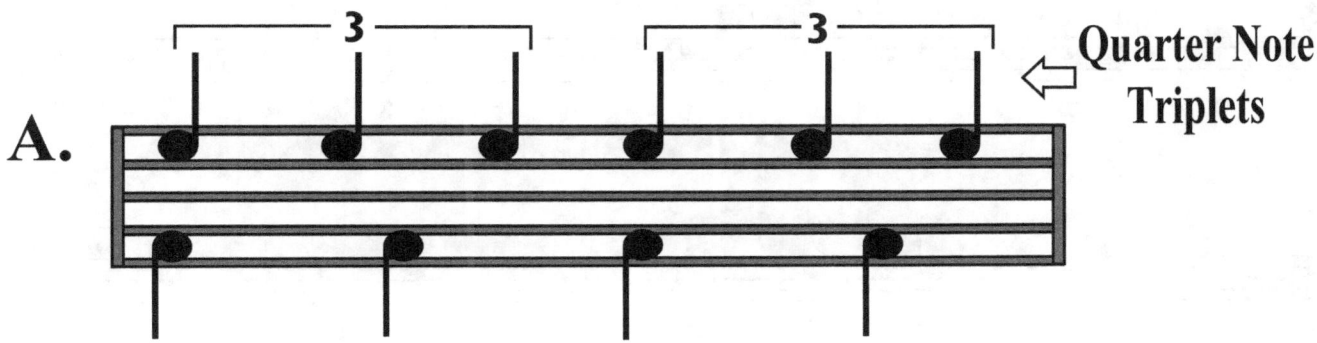

A Triplet is played just the way it sounds. Look at Example **B.**

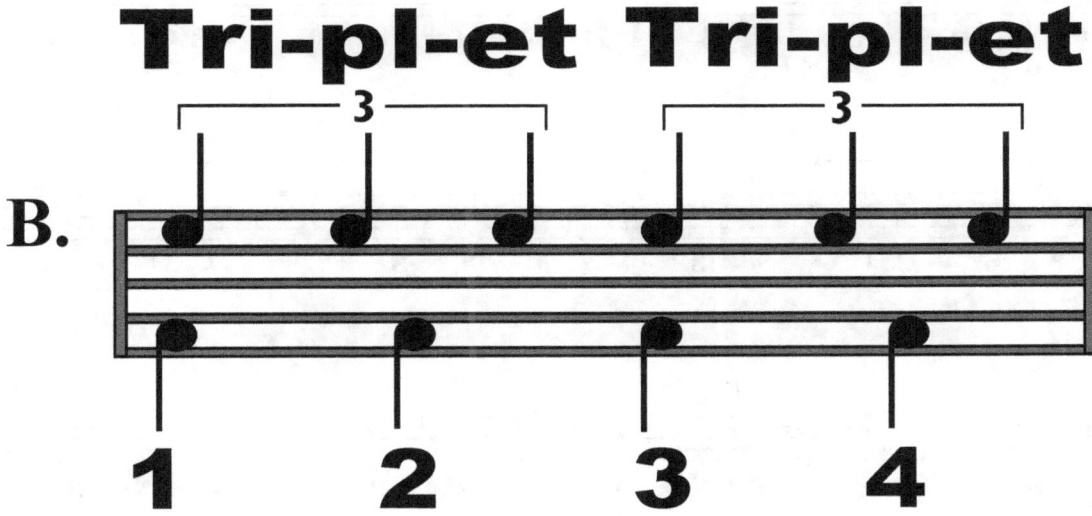

It's very important that you play the Triplets EVENLY with the tempo.
Getting used to this feel might not come right away but it is crucial that you understand how the Triplet is played.

UNDERSTANDING Triplets

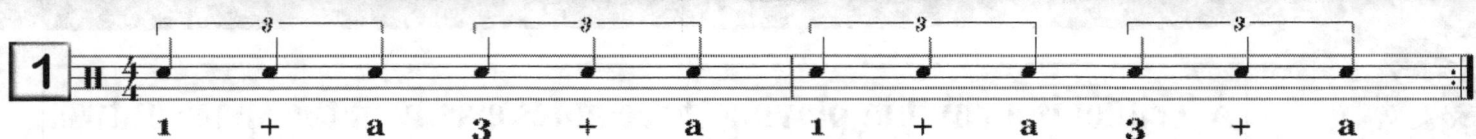
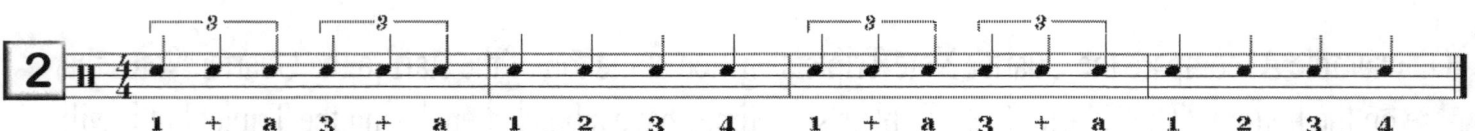
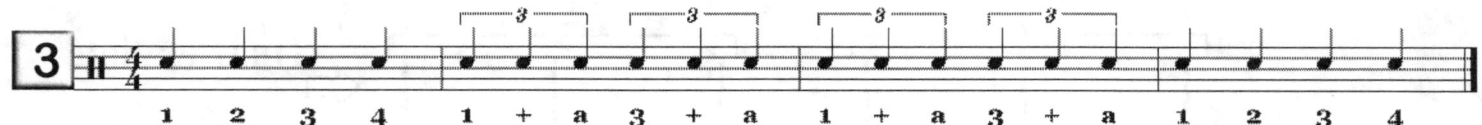
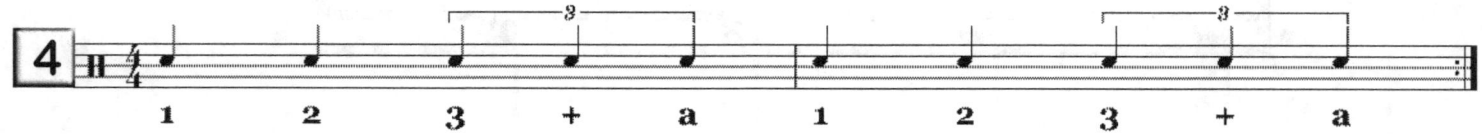
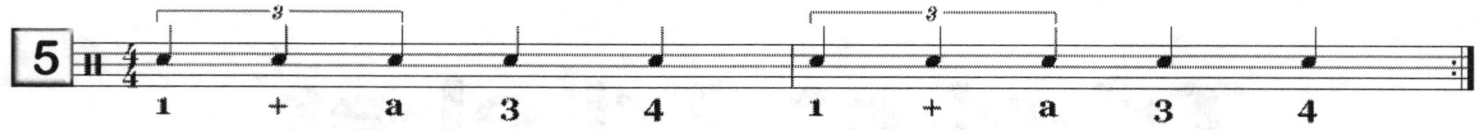
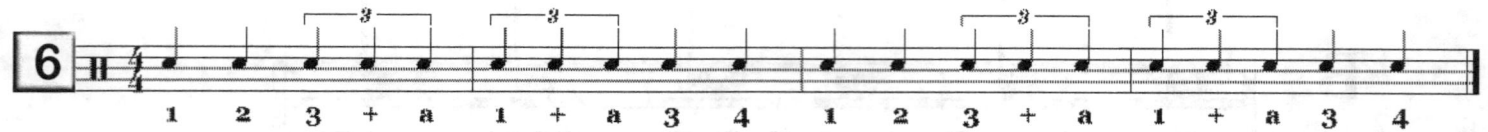
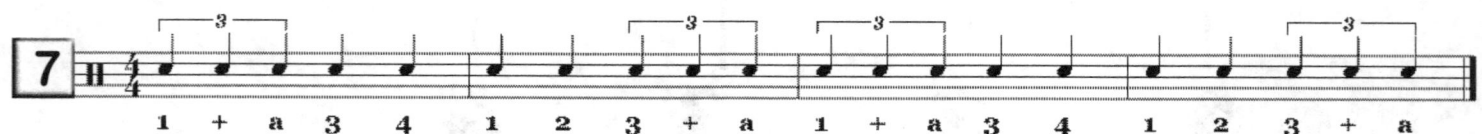

UNDERSTANDING Triplets

Example **A.** compare the Eighth Note Triplets written at the top of the staff to the Eighth Notes that are on the bottom. The Difference between the two is like the Quarter Note Triplet, it also has a 3 written above the notes to indicate that it's a Triplet. Remember that a Triplet is a rhythm playing Three notes **EVENLY** in the space of 2. Where the two Eighth Notes would take up a full beat, now with an Eighth Note Triplet, Three Eighth Notes are going to take up a full Beat and give the notes the Triplet feel.

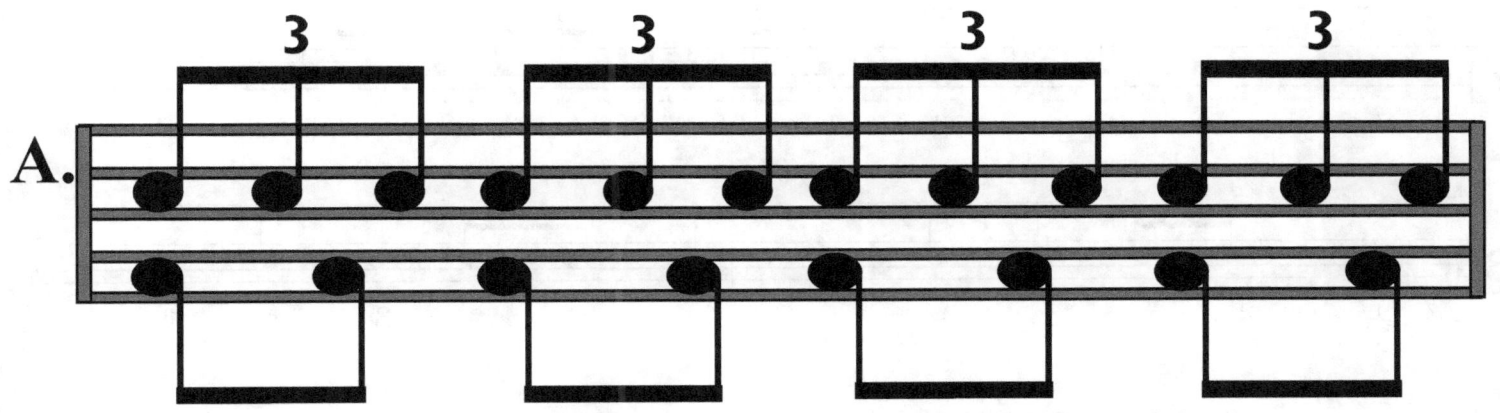

Try these Exercises

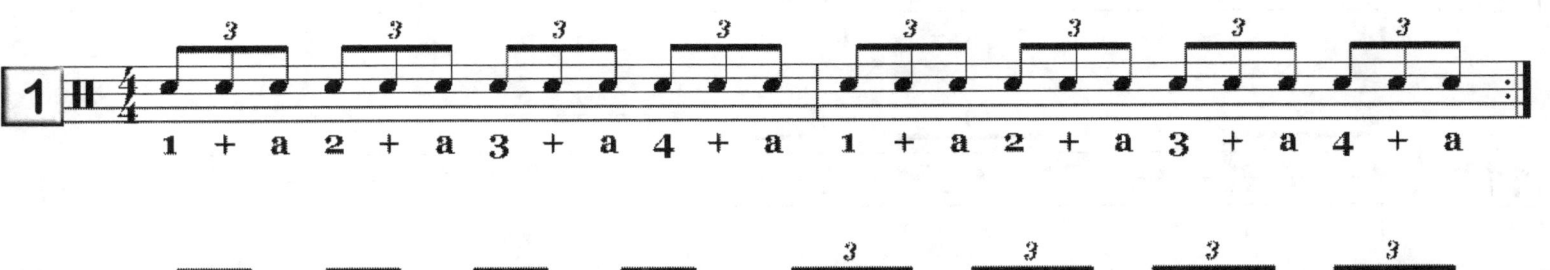

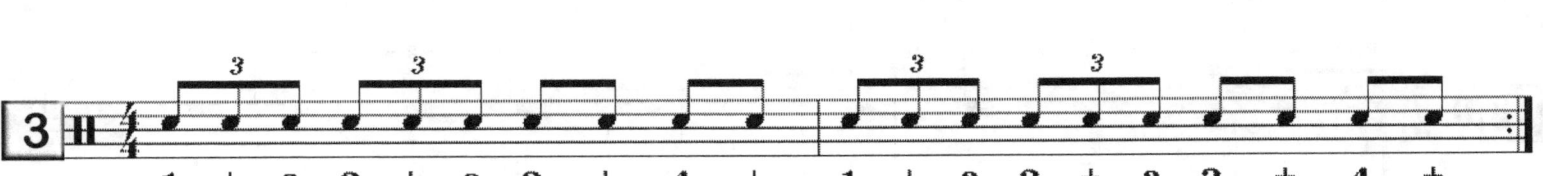

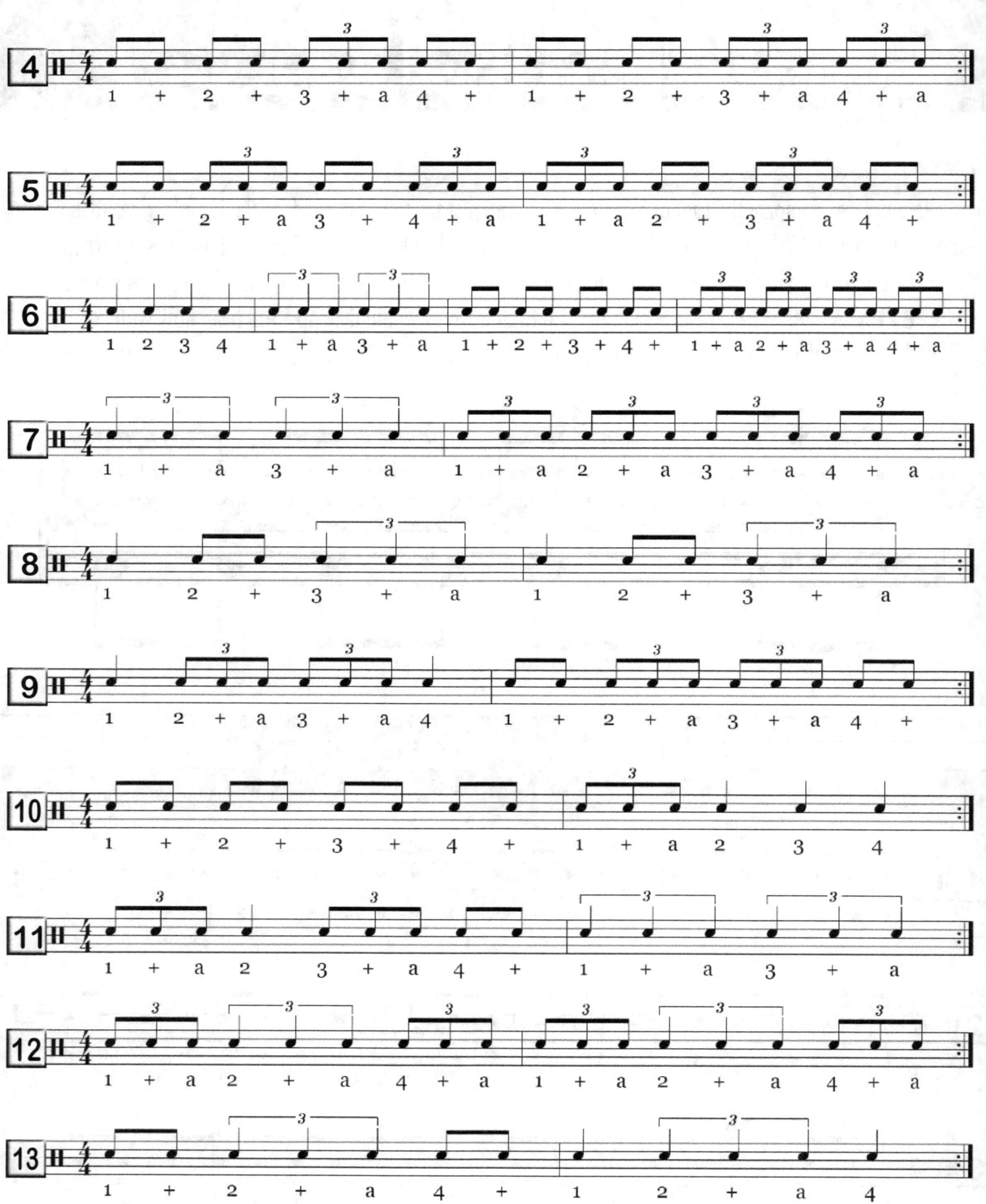

UNDERSTANDING Triplets

Now that you have learned to play Quarter Note and Eighth Note Triplets we're now going to explore the Rest within those Triplets. Triplets are just Quarter Notes and Eighth Notes with a different feel so they use the same Rest depending on the note value within the Triplet.

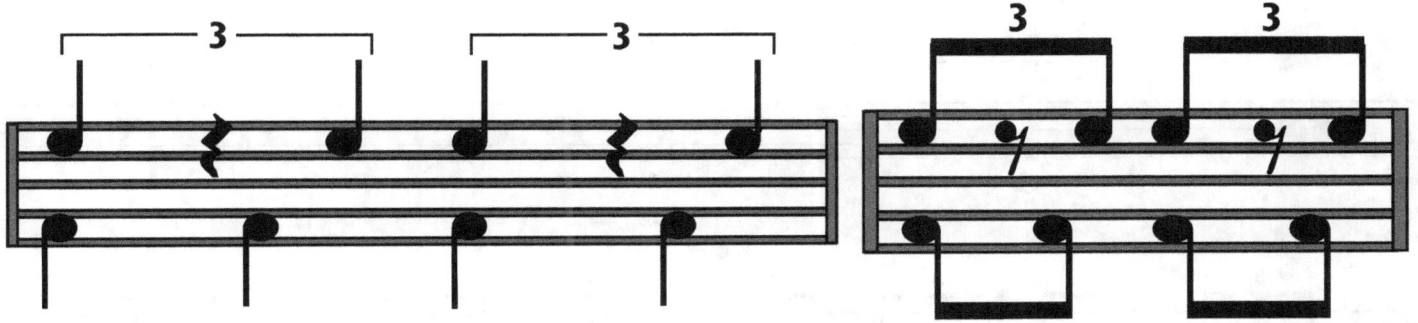

Let's try a couple exercises to get a better understand of the rest inside the Quarter Note or Eighth Note Triplet.

72

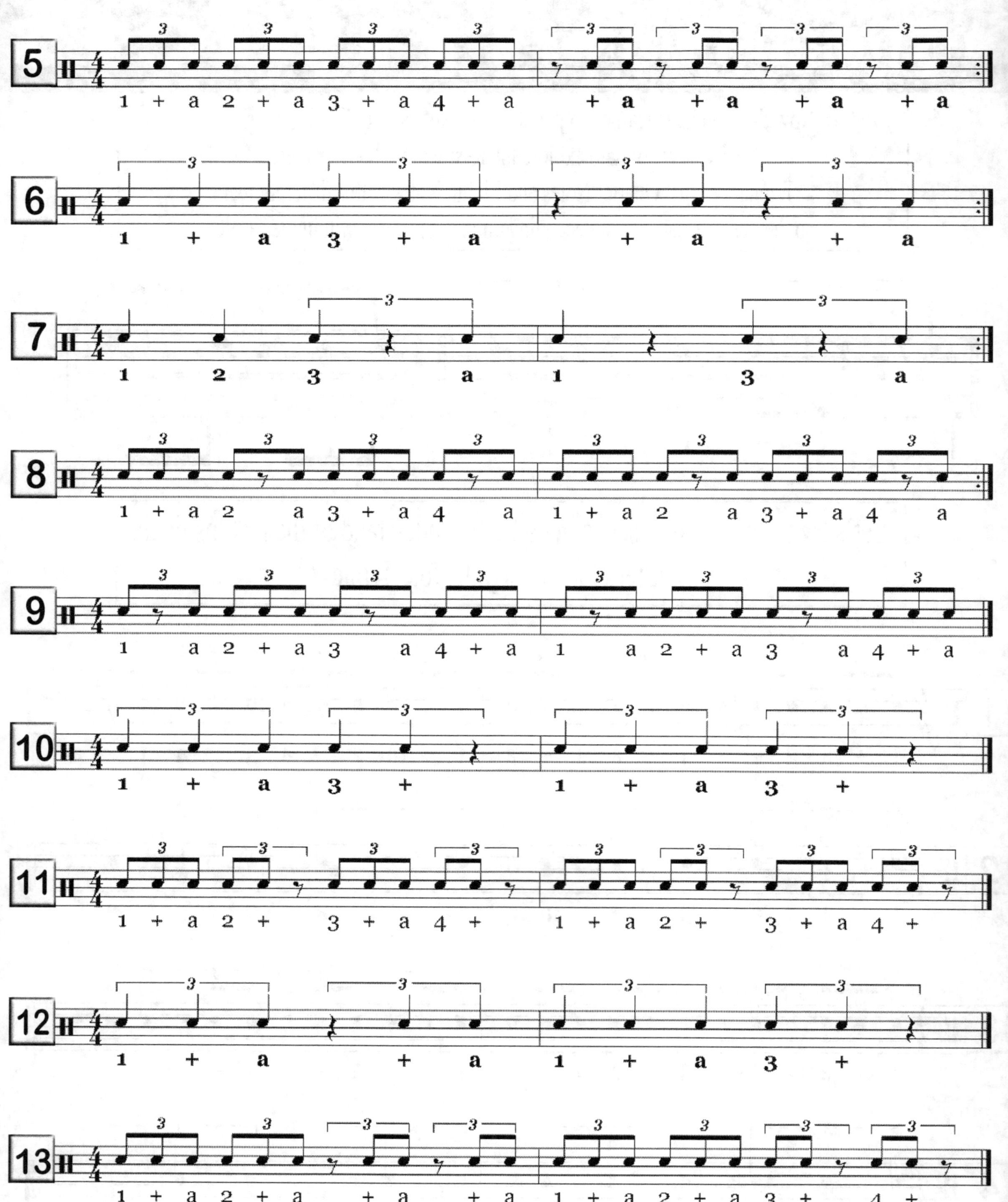

Make It Count

Independent Trips

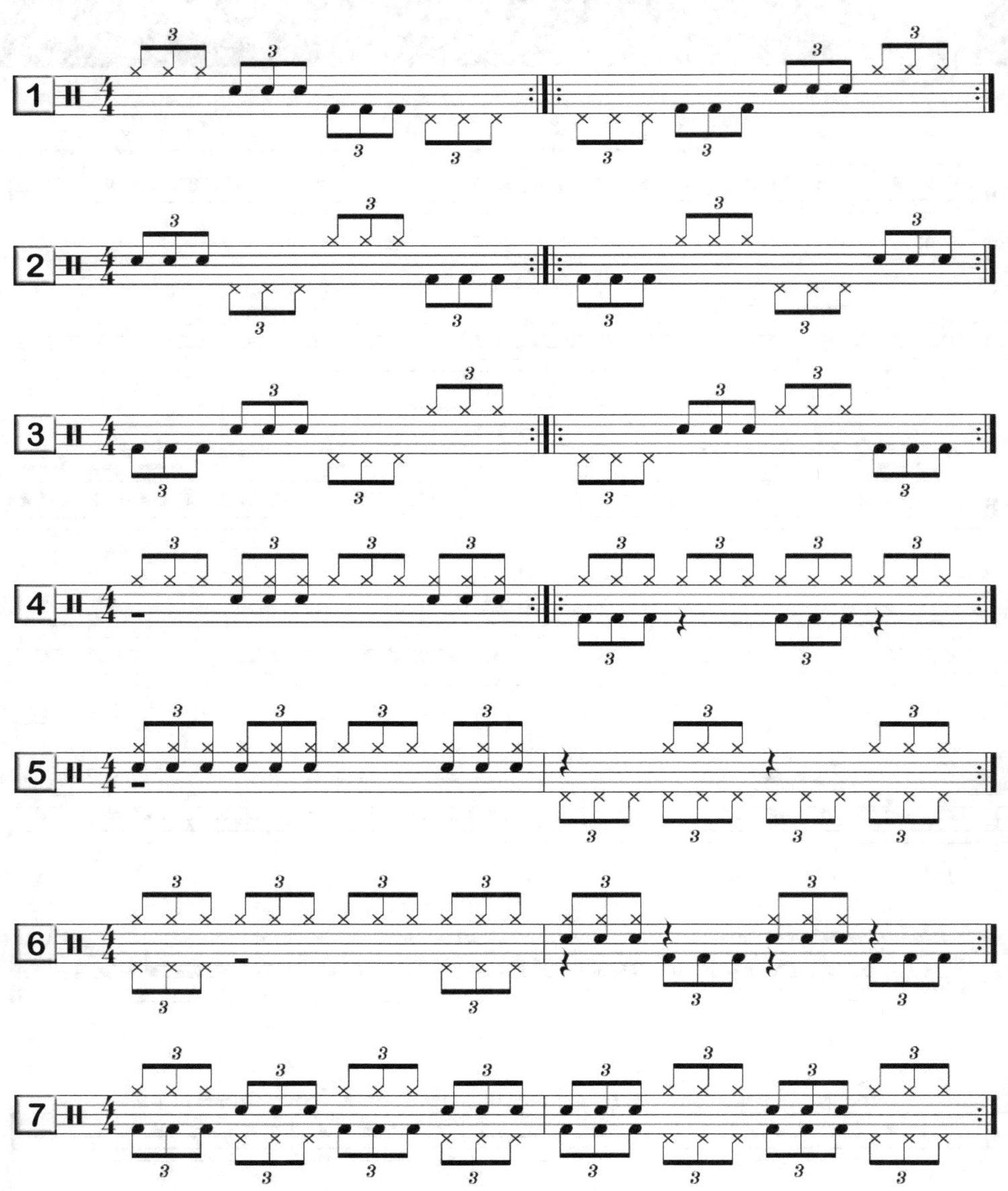

75

Trips on the Snare & Kick

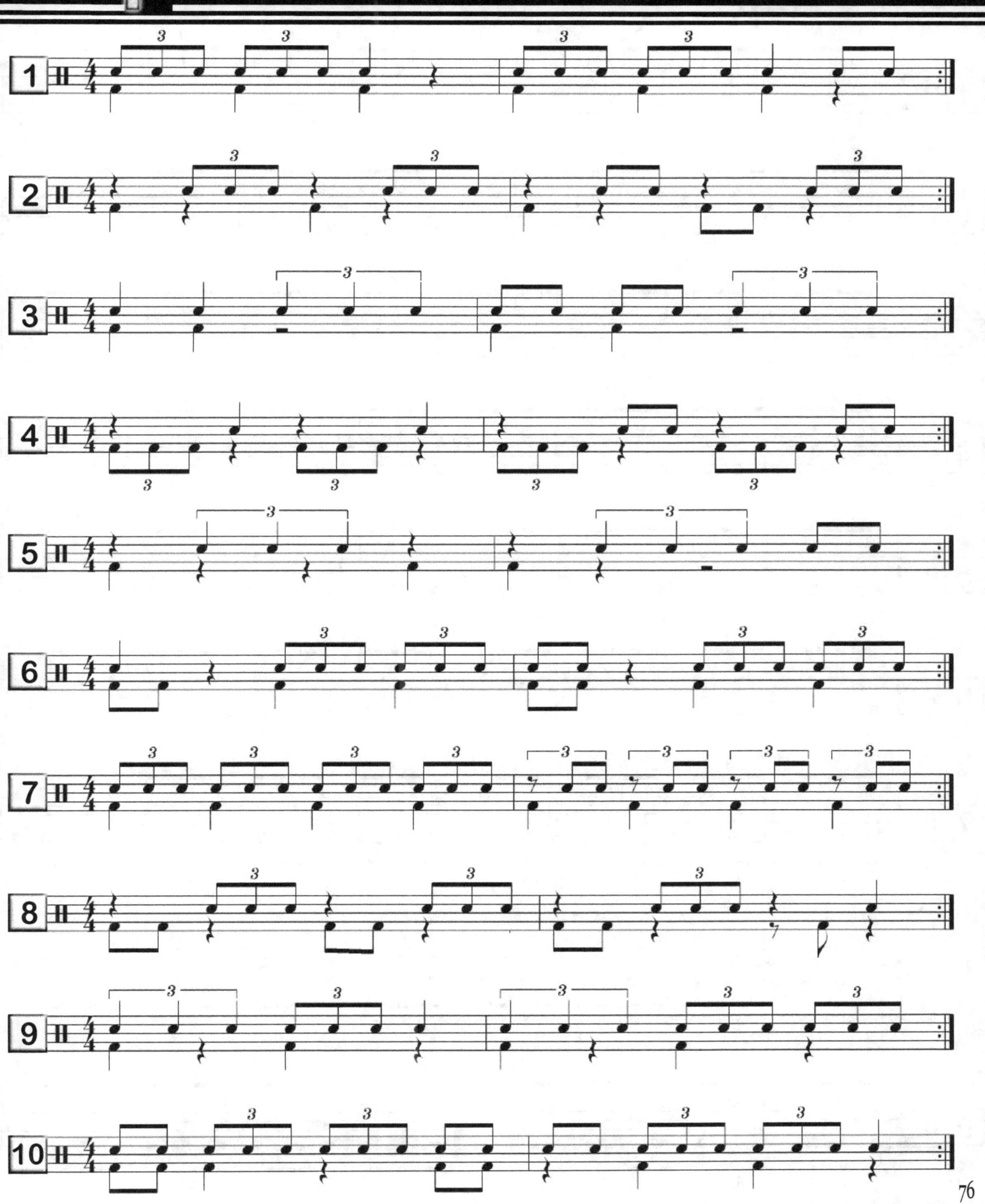

Triplet Grooves

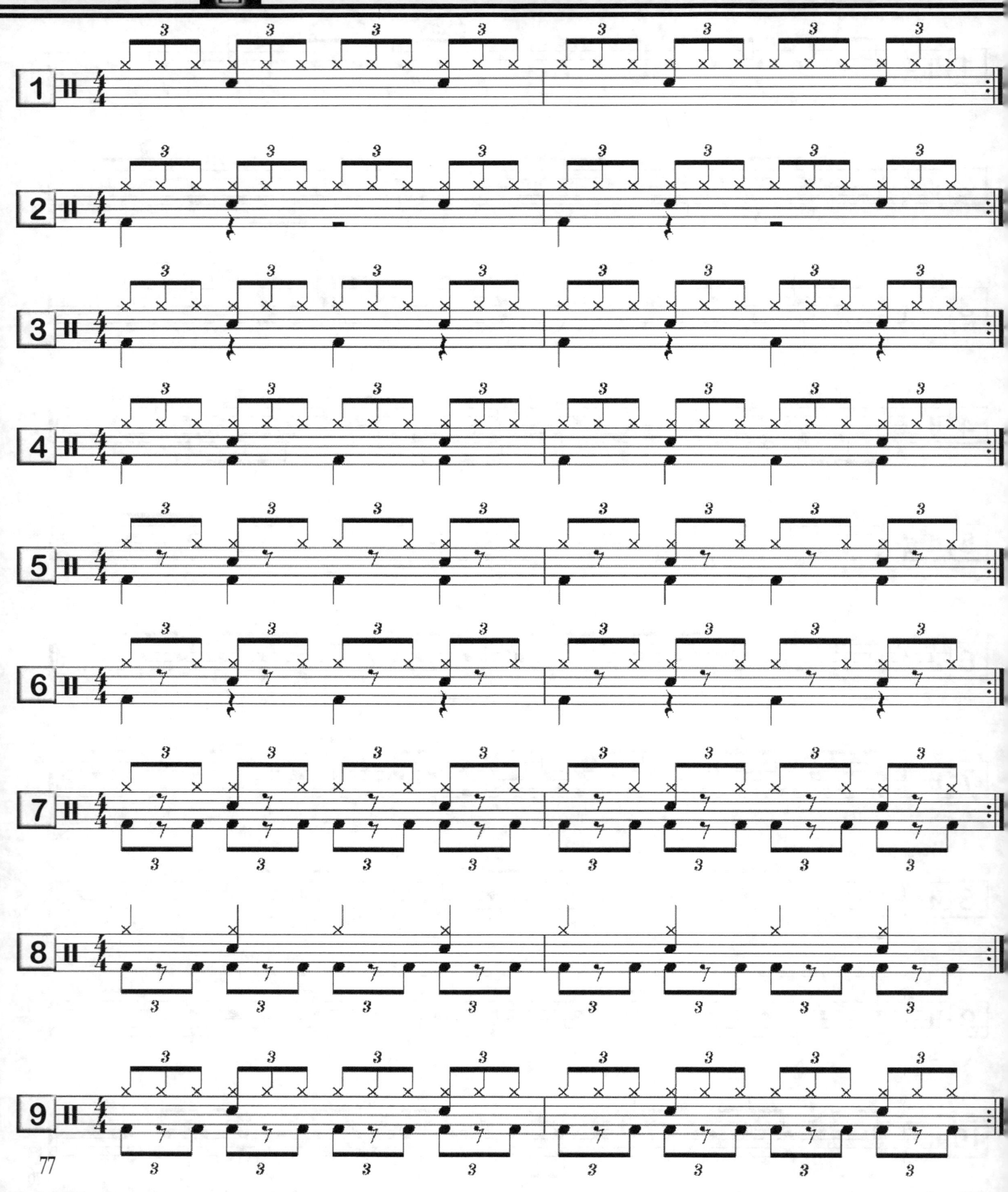

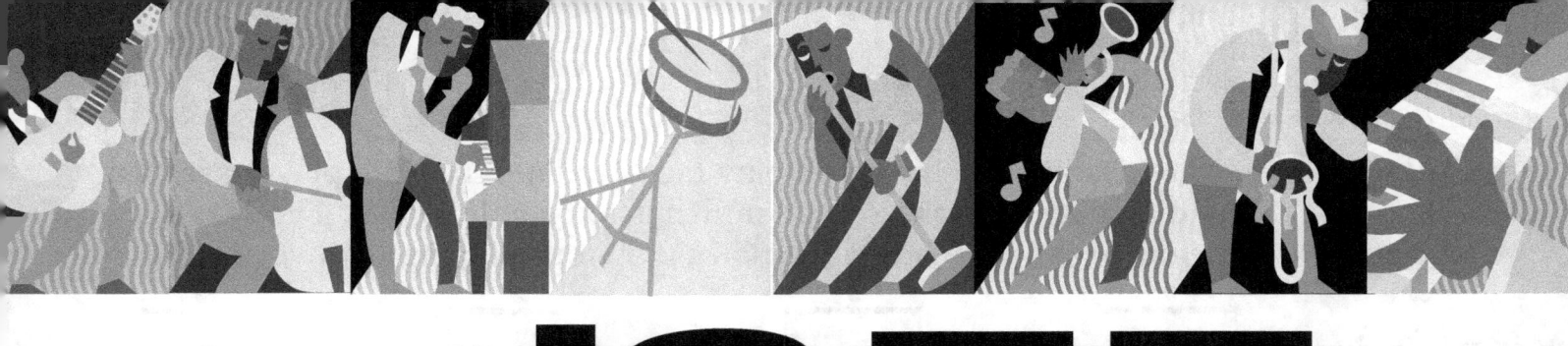

Jazz music

To understand modern music it's important that you recognize it's roots. Jazz was the revolution that happen in the beginning of the 20th century mixing African and European music traditions. As a drummer it's important to have the ability to play a wide variety of music. Rock, Rhythm and Blues, Hip-Hop, Funk, Disco, Country, Bluegrass, Heavy Metal, Pop and Alternative are all popular styles of music that you might enjoy listening to, but they all come from Jazz.

The Jazz Pattern

Step 1

Step 2

Step 3

Step 4

Jazz Pattern Exercises

These exercises are designed to have you play the Jazz Pattern while playing rhythms with your left hand. What you want to accomplish is to be able to play The Jazz Pattern so naturally that you're simply reading the notes that your playing with your left hand.

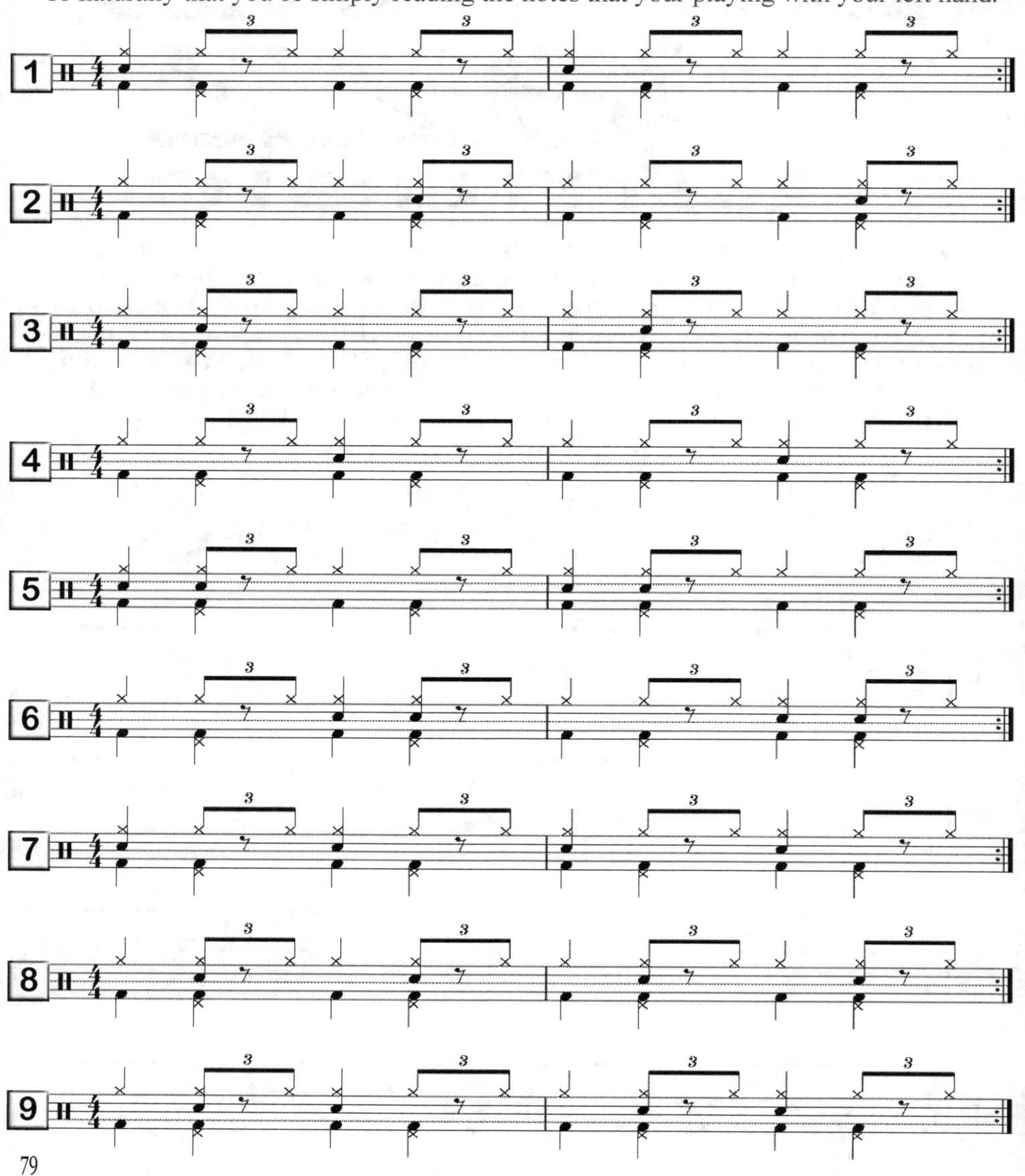

Jazz Pattern Exercises

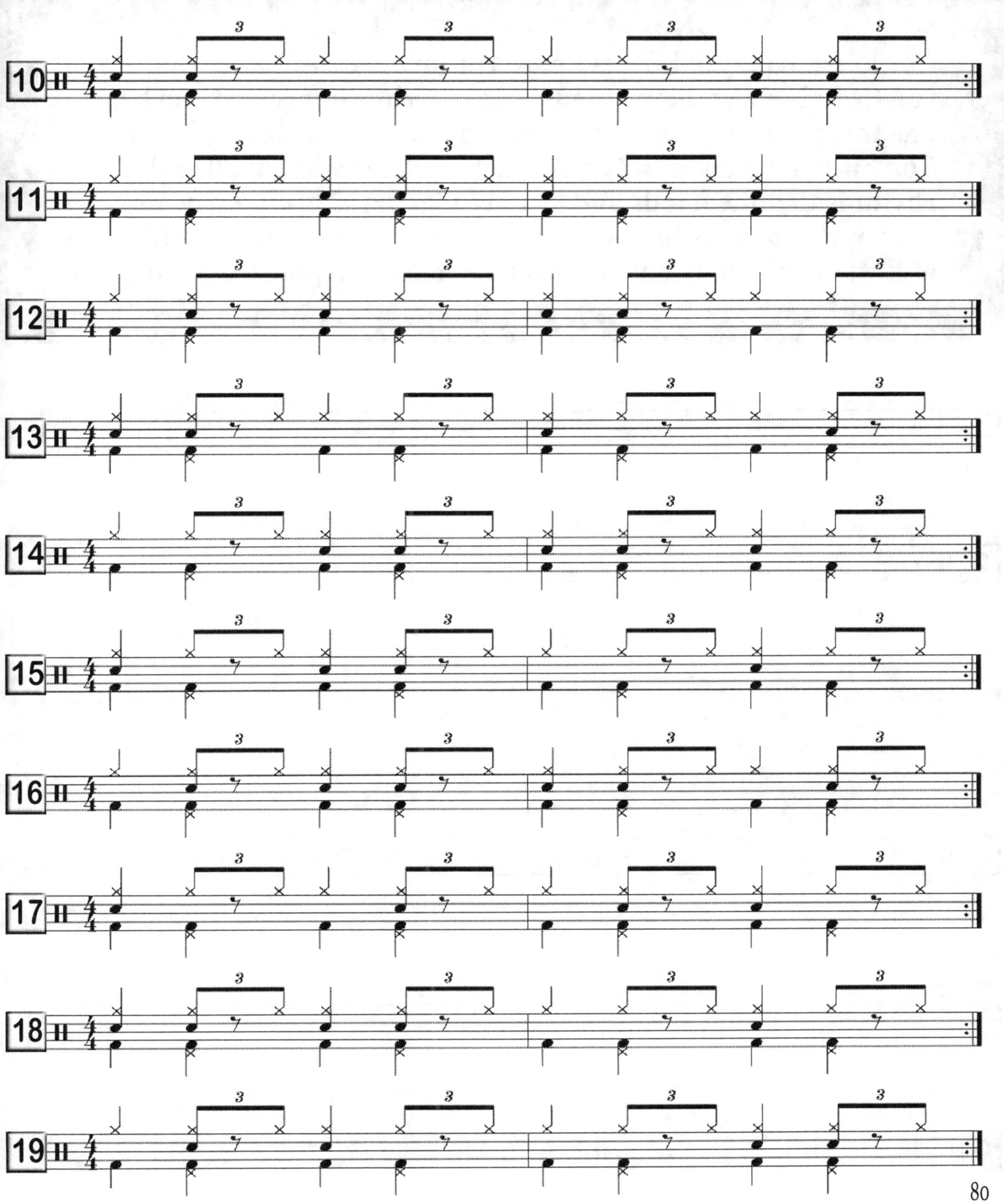

EAR TRAINING

I'm going to play 6 different patterns on the drums and what I want you to do is chart them. Being able to write your own drum beats is one thing, but to be able to chart someone else's playing is another. You have to listen for all of the parts and be aware of all of the rhythms that the hands and feet are playing. This is a true test to how well your ears have developed. I will start with something easy at first and the patterns will become more complicated as we go on.

1 4/4

2 4/4

3 4/4

4 4/4

5 4/4

6 4/4

www.ingramcontent.com/pod-product-compliance
Lightning Source LLC
Chambersburg PA
CBHW080950170526
45158CB00008B/2439